LONDON´s
BRIDGES

Ian Pay
Sampson Lloyd
Keith Waldegrave

Crossing the Royal River

Dedicated to

Marie

and

Claire, Iain, Stuart, Grant and Kylie

in appreciation of all the bridges
that they will have to cross
as they go through life.

LONDON's BRIDGES

Crossing the Royal River

Ian Pay
Sampson Lloyd
Keith Waldegrave

LONDON´s BRIDGES
Crossing the Royal River

Ian Pay, Sampson Lloyd and Keith Waldegrave

Published by

AAPPL Artists' and Photographers' Press Ltd.

Church Farm House, Wisley, Surrey GU23 6QL

info@aappl.com www.aappl.com

Sales and Distribution

UK and Export: Turnaround Publisher Services Ltd | orders@turnaround-uk.com

USA and Canada: Sterling Publishing Inc | sales@sterlingpublishing.com

Australia & New Zealand: Peribo Pty Ltd | michael.coffey@peribo.com.au

South Africa: Trinity Books | trinity@iafrica.com

A catalogue record for this book is available from the British Library.

ISBN 9781904332909

Design (contents and cover): Niki Nekuda | office@nekuda.at

Printed in Singapore by: Imago Publishing | info@imago.co.uk

CONTENTS

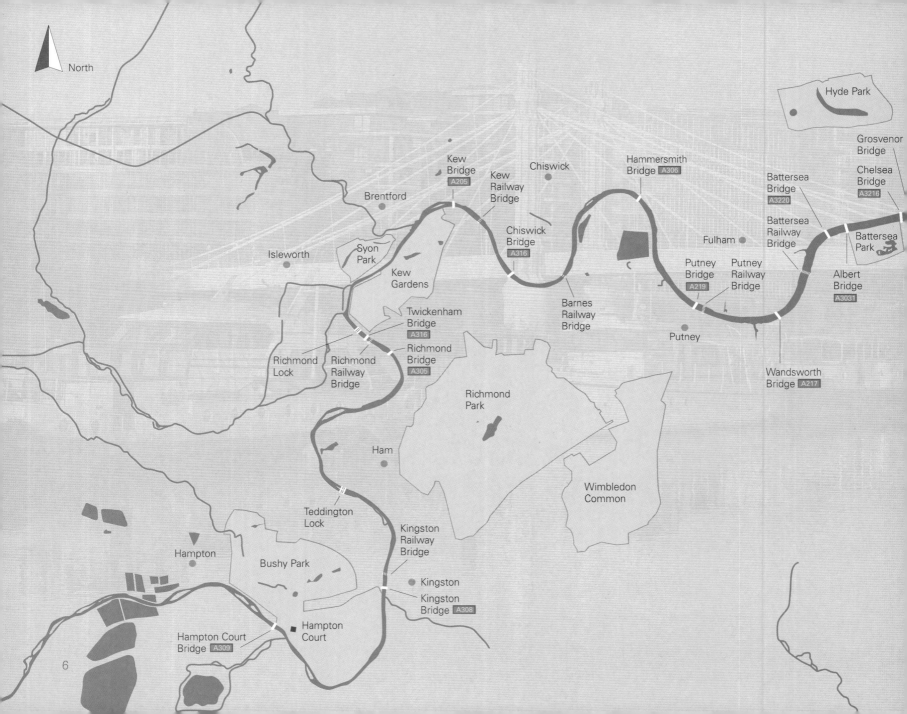

North

Hyde Park

Grosvenor Bridge

Chelsea Bridge A3216

Kew Bridge A205

Chiswick

Hammersmith Bridge A306

Battersea Bridge A3220

Kew Railway Bridge

Battersea Railway Bridge

Battersea Park

Brentford

Chiswick Bridge A316

Fulham

Albert Bridge A3031

Isleworth

Syon Park

Barnes Railway Bridge

Putney Bridge A219

Putney Railway Bridge

Kew Gardens

Twickenham Bridge A316

Richmond Bridge A305

Putney

Richmond Lock

Richmond Railway Bridge

Wandsworth Bridge A217

Richmond Park

Ham

Wimbledon Common

Teddington Lock

Kingston Railway Bridge

Hampton

Bushy Park

Kingston

Kingston Bridge A308

Hampton Court Bridge A309

Hampton Court

6

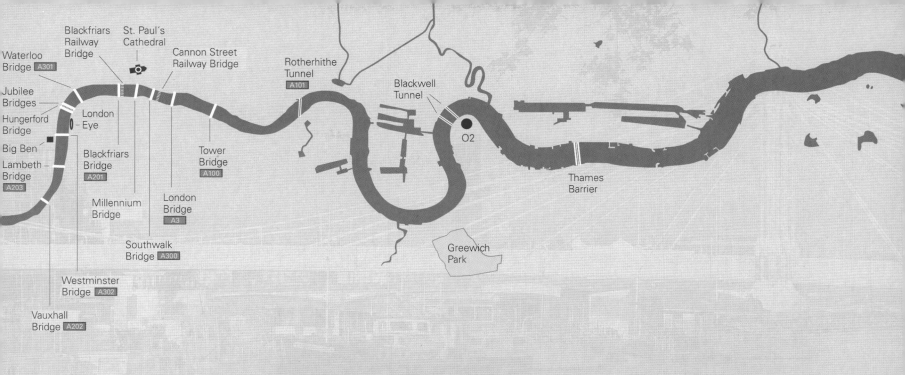

Waterloo Bridge A301

Blackfriars Railway Bridge

St. Paul's Cathedral

Cannon Street Railway Bridge

Rotherhithe Tunnel A101

Blackwell Tunnel

Jubilee Bridges

London Eye

Hungerford Bridge

Big Ben

Blackfriars Bridge A201

Tower Bridge A100

O2

Lambeth Bridge A203

Millennium Bridge

London Bridge A3

Thames Barrier

Southwalk Bridge A300

Westminster Bridge A302

Greewich Park

Vauxhall Bridge A202

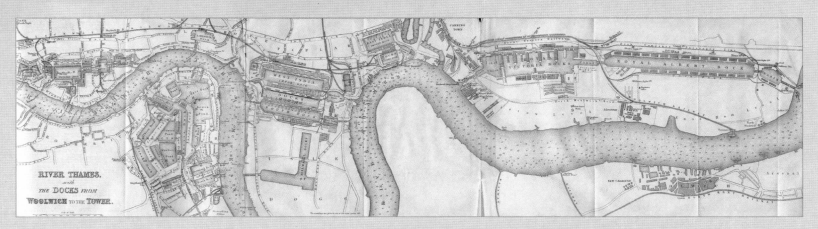

River Thames with the Docks from Woolwich to the Tower, 1882

Introduction

Thirty-three bridges span the Thames over the 23 miles between Hampton Court Bridge to the west of London and Tower Bridge in the east. This is the 'Royal River', the river on which successive kings and queens of England - from Henry VIII onwards - have journeyed to their royal palaces. Some of today's bridges are largely original, while others have been replaced many times. In the case of London Bridge, there have probably been as many as ten different bridges on the current site.

Today, 20 of these bridges are for road traffic (used by more than 625,000 vehicles every day), ten are railway bridges and three are for pedestrians only. They are all a vital part of London's infrastructure, in that they help to keep the city moving, and London's commercial and social expansion is to some extent linked with the development of these bridges.

This book is about the history of the bridges, and about the influential characters who designed and built them. It is about impressive feats of engineering and the role of the Industrial Revolution in the business of bridge-building. It also looks at the artists who have painted the bridges and the poets who have written about them.

Each bridge tells its own story and each offers a comment on the social history of the time when it was built. All have seen their fair share of triumph and tragedy. And every one boasts its own unique personality. Some are plain and functional while others, like Vauxhall Bridge, are decorated with ornate sculptured carvings. They also offer unique views of the city, such as that from London Bridge to Tower Bridge in the early morning mist, or west into the sunset from Westminster Bridge. The view from the middle of the Millennium

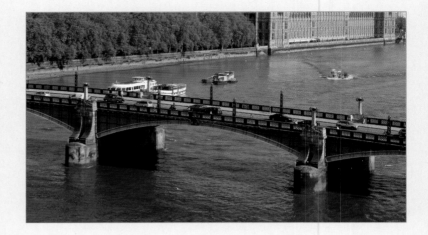

Bridge, with the Thames beneath and St Paul's Cathedral at the northern end, ranks alongside that from the west walkway at the top of Tower Bridge, and in either direction from the centre of Waterloo Bridge, as perhaps the most memorable. Floodlighting the bridges by night only adds to their appeal.

As you move upstream the contrast between the structures becomes apparent. Tower Bridge is an extraordinary engineering achievement, while Albert Bridge boasts a light, almost fairyland effect, and the powerful functionality of the Hammersmith suspension bridge sits somewhere in between.

The bridges are popular meeting places for romantics and lovers, while others just pause a while to take in the views and reflect. They change with the time of day and the season of the year, and it's no wonder that London's bridges have featured in, and indeed been central to the story of, many films. Tower Bridge and Westminster Bridge will always be the most photographed, but every bridge is assured of its own unique place in the history of London. This is their story, as we take a journey of discovery along the Thames.

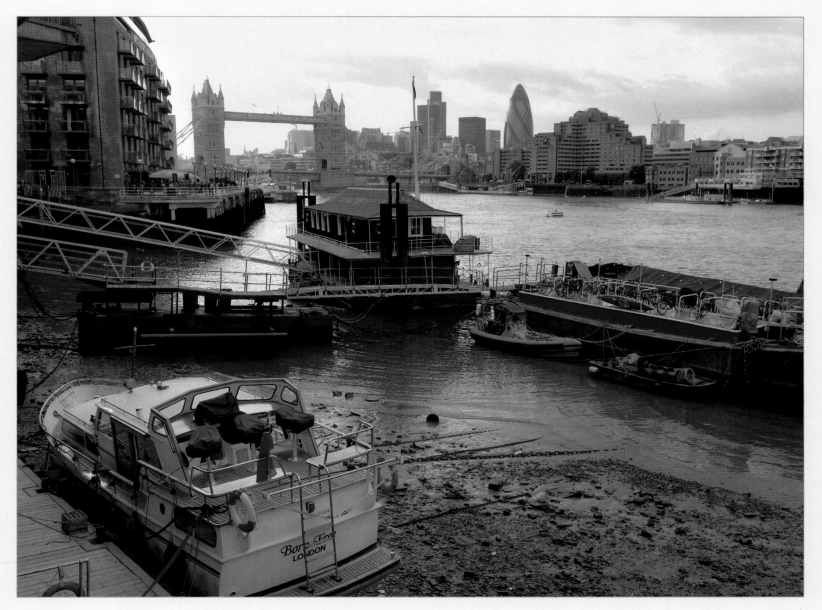

Historical timeline for London's bridges

Monarch	Year	Event
	52	Historians believe the first timber bridge is built by the Romans where London Bridge is today.
	60	Boadicea and the Iceni destroy Londinium and London Bridge
	80	Evidence shows that the Romans rebuilt Londinium and constructed the second London Bridge.
	◄ 100	Londinium is the capital of Roman Britain and has a bridge.
	407	Roman legions leave Britain and the bridge is either dismantled or falls into disrepair.
	842	The Saxon settlement of Lundenwic is built near to the Roman Londinium. This is likely to be the earliest date for a new bridge.
Ethelred	978	
	1000	According to records, tolls are being collected at London Bridge.
	1010	Olaf of Norway pulls down London Bridge.
Hardicanute	1037	
Harold	1066	
William I	1066	
	1081	Building work begins on the Tower of London. ▶
William II (Rufus)	1087	William Rufus, son of William the Conqueror, rebuilds London Bridge.
	1097	London Bridge is destroyed by floods and then rebuilt using local labour.
Henry I	1100	
Stephen	1135	London Bridge is destroyed by fire and rebuilt again.
Henry II	1154	
	1163	Peter de Colechurch is involved with the building of the last wooden London Bridge.
	1176	Henry II announces a tax on wool to fund a stone London Bridge. De Colechurch begins work on it.
Richard I	1189	
John	1199	
	1205	De Colechurch dies. He is buried in the chapel's crypt on London Bridge.

Hardicanute Harold

◄ Olaf of Norway

William I William II Henry I Stephen

Henry II Richard I John

Henry III

	1209	The first stone London Bridge opens. It has houses and a chapel on it with gates at either end. King John gives the Merchants of Kingston permission to build a new bridge.
	1215	Evidence of a wooden bridge at Kingston. It is likely there was also a bridge here in Roman and Saxon times. ▸
Henry III	1216	
	1223	Kingston Bridge renovated.
Edward I	1272	
Edward II	1307	
Edward III	1327	
Richard II	1377	
	1377	The king authorises a levy on vessels passing under Kingston Bridge to fund necessary repairs.
Henry IV	1399	
Henry V	1413	
Henry VI	1422	
	1428	Henry VI renews the Kingston Bridge levy for a further 51 years again to fund more repairs.
Edward IV	1461	
Edward V	1483	
Richard III	1483	
Henry VII	1485	
Henry VIII	1509	
Edward VI	1547	
Mary I	1553	
Elizabeth I	1558	
James I	1603	
Charles I	1625	
	1633	Houses at the northern end of London Bridge are destroyed by fire.
Charles II	1660	

Edward I Edward II Edward III Richard II

London around 1300

Henry IV Henry V Henry VI Edward IV Richard III Henry VII

Henry VIII Edward VI Mary I Elisabeth I James I Charles I Charles II

Kingston Bridge

	1666	The Great Fire of London
James II	1685	
William & Mary	1689	
William III	1694	
Anne	1702	

James II William III Mary II William III Anne George I

The Great Fire 1666

George I	1714	
George II	1727	
	1729	The first Putney Bridge is opened by the Prince of Wales.
	1750	The first Westminster Bridge is opened.
	1753	The first bridge at Hampton Court is opened.
	1759	The first wooden bridge at Kew is opened by the Princess of Wales
George III	1760	
	1763	All the houses are removed from London Bridge.
	1769	The first Blackfriars Bridge is opened. It is originally called William Pitt Bridge.
	1777	Richmond Bridge, designed by James Paine and Kenton Couse, is opened. Today it is the oldest of all of London's crossings.
	1781	The first Battersea Bridge, designed by Henry Holland, is opened.
	1788	The second Hampton Court Bridge is opened.
	1789	James Paine's second Kew Bridge (built of stone) is opened by the king.
	1791	Kingston Bridge is repaired and the Middlesex end widened.
	1795	Battersea Bridge is strengthened.
	1813	London Bridge is badly damaged by severe frosts.
	1816	The first Vauxhall Bridge, designed by James Walker, is opened. It is the first iron bridge to cross the Thames in London.
	1817	The first Waterloo Bridge, designed by John Rennie (the first of his three bridges), is opened.
	1819	The first Southwark Bridge, also designed by John Rennie, is opened.

Westminster Bridge 1750

The first bridge at Hampton Court

Houses on the old London Bridge

The second Hampton Court Bridge

Frost at the Thames 1813

George IV	1820	
	1827	The first Hammersmith Bridge is opened; it is the first suspension bridge to cross the Thames in London. ▸
	1828	A new stone bridge at Kingston, designed by Edward Lapidge, is opened by the Duchess of Clarence.
William IV	1830	
	1831	A new London Bridge, designed by John Rennie, is opened by King William IV and Queen Adelaide.
Victoria	1837	

	1845	Hungerford Bridge, designed by Isambard Kingdom Brunel, is opened as a suspension footbridge.
	1848	Richmond Railway Bridge, designed by Joseph Locke, is opened.
	1849	The first Barnes Railway Bridge, also designed by Joseph Locke, is opened.
	1855	Metropolitan Board of Works created.
	1858	The first Chelsea Bridge, designed by Thomas Page, is opened.
	1859	Hungerford Bridge is bought by the South Eastern Railway Company.
	1860	The first Grosvenor Railway Bridge is opened.
	1862	The second Westminster Bridge, designed by Sir Charles Barry, is opened. The first Lambeth Bridge is opened.
	1863	Kingston Railway Bridge, designed by J E Errington, is opened.
	1863	Battersea Railway Bridge, designed by William Baker, is opened.
	1864	Blackfriars Railway Bridge is opened.
	1864	Hungerford Bridge is rebuilt as a railway/footbridge by Sir John Hawkshaw.
	1865	The third bridge at Hampton Court, which is a new cast-iron bridge, is opened.
	1866	The second Grosvenor Railway Bridge opens next to the first.
	1866	Cannon Street Railway Bridge opens.
	1869	Kew Railway Bridge is opened.
	1869	The second Blackfriars Bridge, designed by Joseph Cubitt, opens.
	1873	The first Wandsworth Bridge is opened.
	1873	Albert Bridge is opened.

George IV William IV

Kingston Railway Bridge

Battersea Railway Bridge

Blackfriars Railway Bridge

	1884	Albert Bridge is strengthened and modernised and has chains added. ▸
	1886	The second Putney Bridge is opened by the Prince of Wales.
	1886	A second Blackfriars Railway Bridge is opened just downstream from the first crossing.
	1887	The current Joseph Bazalgette-designed Hammersmith Bridge is opened by The Prince of Wales
	1889	The footbridge at Teddington Lock is opened.
		Metropolitan Board of Works replaced by London County Council
	1889	Putney Railway Bridge is opened.
	1890	The second Bazalgette-designed Battersea Bridge is opened by Lord Rosebery.
	1893	Cannon Street Railway Bridge is widened and strengthened.
	1894	Richmond Lock and footbridge is opened by the Duke and Duchess of York.
	1894	Tower Bridge, designed by Sir Horace Jones, is opened by the Prince of Wales.
	1895	The second Barnes Railway Bridge (built by Head Wrightson) is opened.

Teddington Lock Footbridge

Edward VII

	1901	
	1902	London Bridge is widened.
	1903	Third Kew Bridge, designed by Sir John Wolfe Barry, is opened by King Edward VII and Queen Alexandra
	1906	Kingston Bridge is widened.
	1906	The second Vauxhall Bridge, designed by Sir Alexander Binnie, is opened by the Prince of Wales.
	1907	A third Grosvenor Railway Bridge is opened next to the first two.
	1908	A second Richmond Railway Bridge is opened.

London Bridge

George V

	1910	Blackfriars Bridge is widened. ▸
	1914	Kingston Bridge is doubled in width but keeps its original appearance. World War I begins.
	1921	The second Southwark Bridge, designed by Basil Mott and Sir Ernest George, is opened.
	1932	The second Lambeth Bridge is opened by King George V and Queen Mary.
	1933	The fourth bridge at Hampton Court, designed by Edwin Lutyens, is opened by the Prince of Wales. He also opens Twickenham and Chiswick bridges on the same day. Putney Bridge is widened to take four lanes of traffic.

| Edward VIII | 1936 | The second Lambeth Bridge is opened by King George V and Queen Mary. |
| George VI | 1936 | |

	1937	Richmond Bridge is widened but still looks the same as the original.
	1937	The second Chelsea Bridge, designed by G Topham Forest, is opened by Rt Hon W L Mackenzie King.
	1939	Start of World War II.
	1940	The second Wandsworth Bridge, designed by Sir Peirson Frank, is opened.
	1945	The second Waterloo Bridge, the Ladies' Bridge, is opened.
Elizabeth II	1952	

Edward VIII

	1960	Cannon Street Railway Bridge is rebuilt.
	1967	Grosvenor Railway Bridge is rebuilt. There are now effectively ten separate bridges.
	1968	John Rennie's London Bridge is sold to Robert P McCulloch of Arizona.
	1981	Cannon Street Railway Bridge is rebuilt by British Rail.
	1984	Richmond Railway Bridge is strengthened.
	1985	The original Blackfriars Railway Bridge is removed, but its piers remain in the river.
	1969	Battersea Railway Bridge is strengthened.
	1973	The current London Bridge is opened by the Queen.
	1992	Battersea Railway Bridge is strengthened again. ▸

Millennium Bridge

	2000	The Millennium Bridge is opened and shut again after two days. A computer system is installed at Tower Bridge to run the raising and lowering of the bascules. Kingston Bridge is widened again, but it still retains the look of Edward Lapidge's original.
	2002	The Millennium Bridge is successfully re-opened. The two Golden Jubilee Bridges, designed by Lifschutz Davidson, are opened either side of Hungerford Bridge.
	2006	An 18-foot northern bottled-nose whale swims up the Thames as far as Battersea Bridge. Albert Bridge is strengthened. Traffic is reduced from three lanes to two.
	2007	Westminster Bridge's stonework is cleaned as part of a £7 million scheme to restore the bridge.

History

In 1999 a team of archaeologists discovered large Bronze Age piles in the Thames at Vauxhall dating back to around 1200BC. This suggests there was a bridge, or at least part of a bridge, over the Thames more than 3,000 years ago. We know that the Romans built a bridge in their city of Londinium in about AD52, and the Saxons erected a bridge where the Tower of London now stands.

In 1176 Henry II imposed a wool tax to help fund the first stone London Bridge, which was then built by Peter de Colechurch. The bridge was started the same year and finished in 1209. It had gates at both ends, as well as a drawbridge, several houses and a chapel.

At about the same time, a timber bridge was being built 22 miles upstream at Kingston. This would be the nearest bridge spanning the Thames to London Bridge for over 500 years. Today there are 29 bridges between the two, so why did it take so long for the other bridges to be built? The reason was quite simple: there was fierce opposition to further bridge-building from the City of London Corporation, which acted as the local authority for the city's jurisdiction, as well as the thousand or so ferrymen and ferry owners, who happened to include successive Archbishops of Canterbury.

For centuries, the watermen and horse ferries, such as those at Lambeth and Fulham, transported people, goods, carts and animals across the river; indeed they were the only alternative to the bridges. The cry of 'oars' or 'ferry' was a familiar call from the stairs along the banks of the Thames. These ferry journeys were often fraught with physical danger however. The risk of capsizing in the fast flowing river meant that many preferred to pay a toll and cross one of the bridges. This trend would eventually put the watermen out of business. The City Corporation, which scrupulously regulated London's wealth, was therefore against bridge building. The corporation also wanted its citizens to stay within the city's boundaries rather than to start an urban sprawl along the riverbank.

However, a rising population meant that London soon became overcrowded, with everyone wanting to live and work near London Bridge. The houses were very close together and the streets very narrow and sewage disposal quickly became a major problem. Those who could afford to preferred to live in the houses on London Bridge itself where the river air was somewhat cleaner, and the Bridge soon became a 'town on the river', where a thriving community of townspeople, merchants and vagabonds all lived together.

Landowners with property and estates on either side of the river saw the potential to make money and lobbied to build bridges linking the north and south banks, most notably between Westminster and Lambeth. When, in the 1630s, one of their schemes appeared to have a good chance of being approved, the City Corporation offered Charles I a loan of £100,000 to refuse it permission. He took the 'loan' and the plans for the bridge were dropped.

Parliament was then lobbied continuously for more than a hundred years to pass an act allowing a bridge to be built at Westminster. In fact the first bridge to be built between London Bridge and Kingston Bridge was Putney Bridge (originally known as Fulham Bridge). In an Act of Parliament in 1726, George I gave his assent to the building of this timber toll bridge linking Putney and Fulham.

Finally, in 1736, the Earl of Pembroke and his Company of Gentlemen overcame all further opposition and obtained permission to build a bridge at Westminster. Monies were to be raised from five public lotteries, but they didn't generate as much as expected. Reluctantly, the government agreed a financial grant to allow the bridge to be built

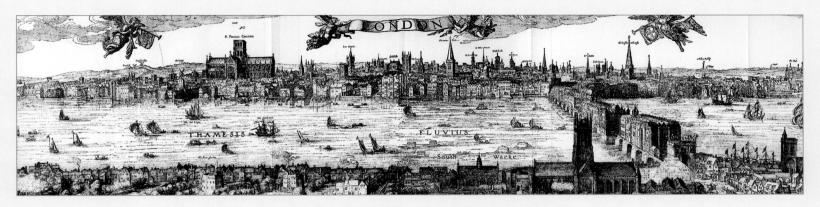

Panorama of London, Claes Van Visscher, 1616

and it eventually opened in 1750.

The breakthrough having been made, 16 more bridges were built across the Thames over the next hundred years. The most frenetic period, however, was during Queen Victoria's reign (1837 - 1901) when a further 28 bridges were built. The watermen, understandably, were particularly vocal in their opposition to the increased activity, and considerable compensatory payments were made to them and their dependents.

The approaches to these early bridges were either non-existent or poorly made and maintained, and they were often too steep for horses and carts. Then, to make matters worse, the bridges themselves were unstable. They were usually built with a large number of arches - deemed necessary for building over long distances - but the piers became a major obstacle for boats and barges, which regularly knocked into them, damaging both bridge and boat. Continuous river scour added to the problem, eroding the foundations and causing the bridges to become rickety and precarious. As they were pulled down and rebuilt, the number of arches per bridge decreased.

The Industrial Revolution had a dramatic impact on the art of bridge building. The use of iron, along with the development of other new materials, skills and techniques, allowed a significant increase in bridge construction. It also heralded the arrival of the railways and with them the many railway bridges to carry new trains across the Thames into London. However, the Industrial Revolution also brought an estimated eighteen million tons of coal into the capital annually by the end of the 19th century. Louis C Parkes, a health official in Chelsea, claimed in 1892 that the burning of this coal meant 'over two hundred tons of fine soot was going into London's atmosphere daily'.

Bridges were both costly to build and expensive to maintain. Nearly all of them were privately funded, there being only two exceptions Chelsea and Westminster, which were paid for with public money. And almost all started off as toll bridges, of which many proved to be a significant source of income for their owners. Most bridges, however, never realized the expected profit, and some only returned a miserly sum. Countless investors ended up losing money, with many more not receiving the dividends they were expecting from their investment.

Most of the bridges were therefore sold on, and the Metropolitan Board of Works, which became responsible for their upkeep and safety, bought many of them. Before long, they were all freed from toll.

When it became apparent that a new bridge was needed, there would often be a competition to design and build it. At the opening of a new bridge there would be a grand celebration, which sometimes even happened at lesser events, such as at the laying of the foundation stone.

Bridge building over the Thames has moved on from rickety wooden structures with suspect foundations to magnificent cantilever steel structures carrying four lanes of traffic into the heart of London. The bridging of the Thames is intimately entwined with the social history and the culture of London and its development into one of the greatest cities in the world. The bridges have helped make London one city by joining together the different communities on the banks of the river.

Interestingly, none of the bridges has retained the name of a monarch or prime minister for any length of time. Kew Bridge was known as Edward VII Bridge for a few years around the turn of the 19th century but it quickly became known as Kew Bridge again. The bridge initially named Victoria Bridge (in 1858) was soon renamed Chelsea Bridge, probably because it was found to be unstable and the authorities didn't want the queen to be associated with a structure that might collapse. Blackfriars Bridge was originally called William Pitt Bridge but it was changed to Blackfriars when the prime minister became less popular.

Amazingly Waterloo was the only bridge in London to be damaged by the German bombers in World War II, although Cannon Street railway station was hit and a bomb did bounce off the 'cross bar' on

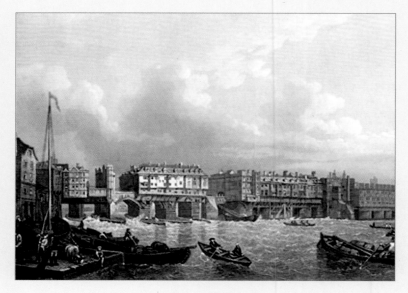

Vauxhall Bridge, Samuel Bentham, 1829

London Bridge, 1745

Tower Bridge before landing in the river.

Artists have been painting London's bridges for hundreds of years. Claude Monet, who regularly came to London to paint, said to his dealer, 'I adore London…but what I love more than anything is the fog.' He was talking about the smog of course, the strange mixture of smoke and fog that hung over London at the turn of the 20th century.

The bridges have been written about by poets, featured in films and sung about in popular song. They have seen murders and suicides, witnessed love and romance, have been the focal point of both great celebrations and sadness. They have seen magnificent ships visiting the Port Of London at Tower Bridge, and close Boat Race finishes at Chiswick Bridge. They form part of the arterial network at the heart of a great city, linking north to south and east to west.

This is the history of these spectacular bridges.

Author's Note
Upstream from east to west

London's Bridges is about the 33 bridges crossing the River Thames over a 23 mile stretch between Tower Bridge in the east and Hampton Court Bridge in the west.

I have taken the journey upstream from east to west as this is the way invaders and merchants would have sailed upriver from the North Sea in earlier times. It also means that London Bridge, the oldest of the bridges, and Tower Bridge, arguably the most spectacular, can take their rightful place in the early pages of the book.

I hope you enjoy it.

Ian Pay, 2009

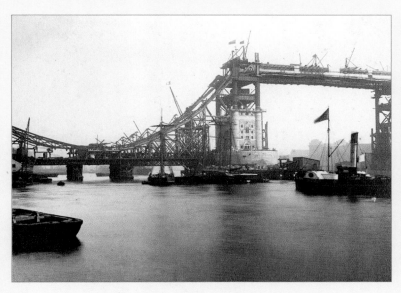

Tower Bridge under construction, 1892

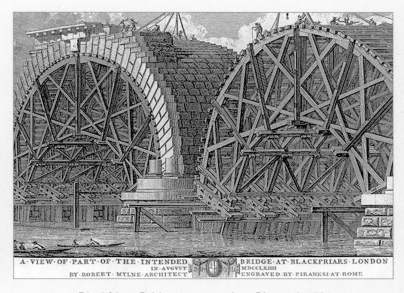

Blackfriars Bridge construction, Piranesi, 1764

Tower Bridge
An iconic London landmark.

Tower Bridge, possibly the most recognisable bridge in Britain, is one of the world's iconic landmarks. One of London's principal attractions, it is as famous as the Eiffel Tower in Paris, the Coliseum in Rome, and the Statue of Liberty in New York. It is the easternmost of all London's bridges and links Tower Hill on the north bank with Tooley Street in Southwark. It was opened by the Prince of Wales on 30 June 1894, and is 880 feet long, 213 feet high and 60 feet wide. He had previously laid the bridge foundation stone on 21 June 1886.

This double-bascule (a moveable structure with counterweights to balance the two spans) bridge was originally built to accommodate both sailing ships with tall masts and passenger liners using the Upper Pool (the section of river between London and Tower Bridges) of London beside the bridge. Sadly, the era of these ships was coming to an end as the bridge was completed.

Increasing traffic congestion over London Bridge at the end of the 19th century meant that an additional bridge was needed to the east. More than fifty different submissions were put before parliament and the City Council. Some suggested building a new bridge, while others proposed widening the existing London Bridge. Finally it was decided that a competition should be held to design a new bridge. There were two fundamental requirements: there had to be a minimum of 160 feet of clear water in the middle of the river throughout construction, so that there was no disruption to shipping in the Pool of London, and large ocean going ships must be able to pass underneath the bridge.

It seems that the name Tower Bridge originally came from Sir Joseph Bazalgette's design for a huge single-span iron bridge. Unfortunately

Bazalgette's submission didn't win the competition, that honour going to Sir Horace Jones, albeit in very strange circumstances. As an architect Jones was sitting on the panel of judges evaluating the submissions where he had the distinct advantage of seeing all the entries. In fact he was even asked by the other judges to give a technical appraisal of Bazalgette's design, which they eventually rejected because the approaches were believed to be too steep for horses. Then various bridge, ferry and tunnel entries were also discarded. Bridge House Estates decided to ask John Wolfe Barry to look at Horace Jones's own plans from an engineering perspective. Jones's design, with some modifications, was accepted, and in August 1885 it was approved by parliament, with an estimated building time of five years and a cost of £750,000.

Construction started in 1886, though it actually took eight years to complete the project and cost over £1,000,000. Five major contractors and 432 workers were employed, 57 of whom lost their lives while working on the bridge. Sir Horace Jones died from heart disease a year after work started and didn't see his bridge finished. Now his chief engineer, Sir John Wolfe Barry was given responsibility for the finishing project, with the assistance of George Daniel Stevenson and Henri Marc Brunel, second son of Isambard Kingdom Brunel.

They sank two huge piers, each 185 feet long and 70 feet wide into the riverbed with over 70,000 tons of concrete, while 11,000 tons of steel were used in the framework of the towers and walkways. Two of the four towers are built on the piers and clad in Cornish granite and Portland stone, though Sir John Wolfe Barry altered Horace Jones's planned facade to a more ornate Victorian gothic style. The 200-foot central span is split into two bascules, which can be raised to an angle of 83 degrees to allow river traffic to pass through. The bascules, which work like a see-saw (indeed bascule is the French word for see-saw

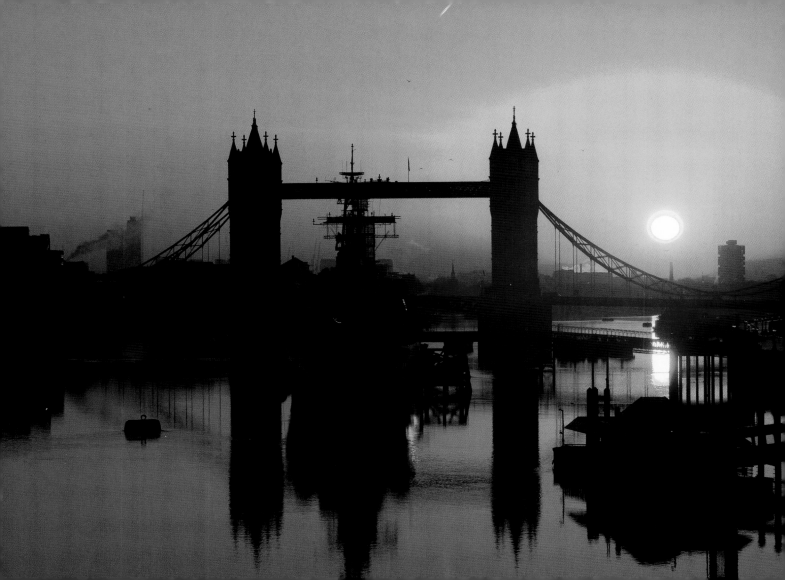

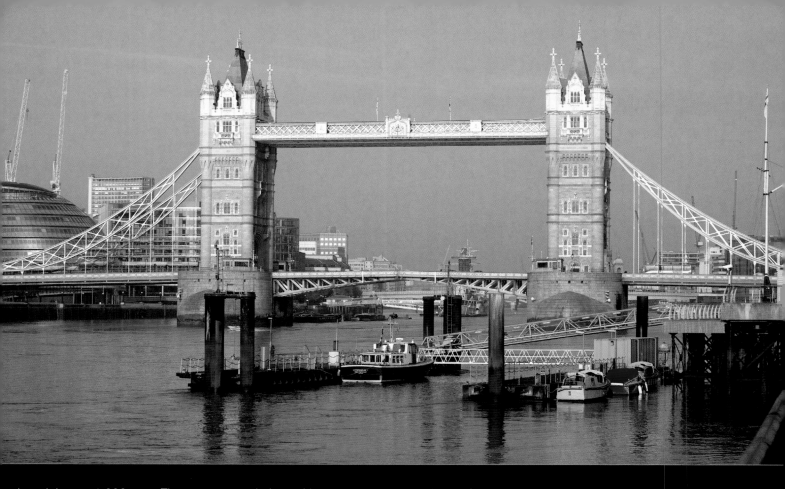

each weigh over 1,000 tons. They are counterbalanced by a 422-ton iron and lead weight to reduce the energy required to raise them. The first hydraulic raising machinery, which is now on public display, was run by steam. Today it is oil powered, and electric motors have replaced the steam engines and accumulators.

At 143 feet above the Thames, the high level walkways between the two towers were intended for busy pedestrians who didn't want to wait for the bridge to open and close. They were rarely used, however, with most people preferring to wait and watch the bridge in action. In fact, the walkways soon became a notorious haunt for pickpockets

prostitutes and suicides, and they were closed in 1910. When the bridge was restored in 1982 they were glassed in and reopened as part of the Tower Bridge Tour. The views of London and the Thames are quite breathtaking from this vantage point, while the walkways' windows have been specially designed to allow visitors to take unobstructed photographs.

In 2000 a computer system was installed to remotely control the raising and lowering of the bascules. When the bridge was first opened it needed a crew of 80 (mainly stokers) to keep the furnaces at full steam, so that the bridge was operational round the clock. They worked under the direction of the Bridge Master and a Superintendent Engineer. On average, the bridge was opened 17 times a day when it was first built, but this number gradually reduced as ships grew larger and they didn't venture as far upstream. In recent years it only opens two or three times a day, though shipping still has priority over the 40,000 vehicles that use the bridge daily. The bridge takes between three and five minutes to open. One man can control it by simply pushing a button, although another is always on duty to back him up for safety reasons. A 24-hour advance warning must be given to the Bridge Master for the bascules to be raised.

There have been very few accidents involving the bridge, even though in a 1912 emergency Frank McClean flew his biplane between the towers and under the walkways. On 28 December 1952 Albert Gunter's number 78 double-decker bus got caught on the end of one of the bascules as the bridge opened and he had to leap several feet to safety on the other side. Fortunately there were no casualties. The bridge is currently painted light blue and white and is owned and maintained by Bridge House Estates. The St. George and Union Jack flags fly proudly from the top of the bridge. The Tower Bridge Tour is highly recommended.

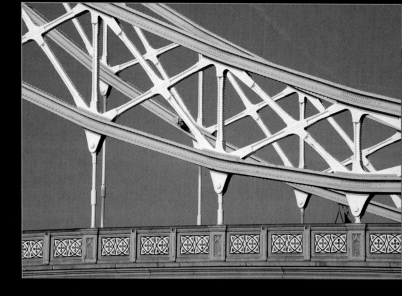

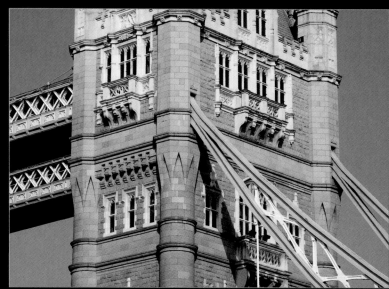

London Bridge

The site of the first bridge over the Thames in London.

London Bridge is the most famous of all the capital's bridges and certainly boasts the most interesting history. The current crossing links the City of London to the north of the river with Southwark in the south. It is used by an average of 38,000 vehicles every day, as well as many thousands of pedestrians.

Lord Holford designed the bridge we have today, and, having been part-funded by Bridge House Estates (who now own it outright), it was built by John Mowlem & Co. using engineers Mott, Hay & Anderson. It is a concrete bridge with three hollow boxed girders of reinforced concrete, polished granite panels and a wide stainless steel handrail. Both the six-lane road and wide pavement can be heated in winter. HM Queen Elizabeth II opened the bridge on 16 March 1973 and there is a plaque at its centre commemorating the event.

There has been a bridge of some description on this site for over 2,000 years however; indeed London Bridge was the first to cross the Thames. It is thought that the Romans had built a timber bridge here by AD52, though the archaeological and historical records suggest it may have been even earlier. This bridge effectively linked the south and north of the country, as well as being an entrance to the Roman city of Londinium.

The bridge would have been built where the river was narrow enough to make it bridgeable, but also sufficiently deep for sea-going ships to pass. In AD60 Queen Boadicea and the Iceni razed Londinium to the ground, destroying the bridge, though the Romans rebuilt it in around AD80, this time from the Southwark settlement. After the Romans left Britain, the wooden bridge is likely to have collapsed and was probably replaced by a ferry. More timber bridges were built on the same site during the later Saxon era, however.

In 1014, with the Danes ruling London, a Viking raiding party led by King Olaf of Norway sailed up the Thames and helped King Ethelred attack the bridge. They rowed underneath it, attached chains to the piles supporting the bridge and then rowed away on the tide. This is where the song 'London Bridge is Falling Down', is believed to have originated.

Two more timber bridges were built and destroyed; one was swept away in a storm in 1091, and the other was destroyed by fire in 1136. In 1163 priest Peter de Colechurch used elm to build another wooden bridge, but all these wooden structures were vulnerable to fire, flood and storm, and his ambition was to build a stone bridge that could withstand the elements. To us it may seem strange that a priest was involved in bridge building, but in 12th-century Britain it was seen as an act of piety. Indeed throughout Europe many priests were similarly engaged, which might help explain why so many bridges had a built-in chapel.

Peter de Colechurch started the first stone London Bridge in 1176 with money raised by Henry II's wool tax. The bridge had to span 905 feet of tidal water and would take 33 years to build, lasting through the reigns of the next three monarchs, Henry II, Richard-the-Lionheart and King John. It would cost the lives of an estimated 150 workmen. The bridge eventually boasted a road 20 feet wide and 300 yards long, which was supported by 19 arches and a drawbridge, with a gatehouse at each end. A chapel, which was dedicated to Thomas Becket, was built at the centre of the bridge. De Colechurch died in 1205, four years before completion, and he was buried in its crypt. Mason William Alemain, along with a number of city merchants, some of whom would later become bridge wardens, finished his work.

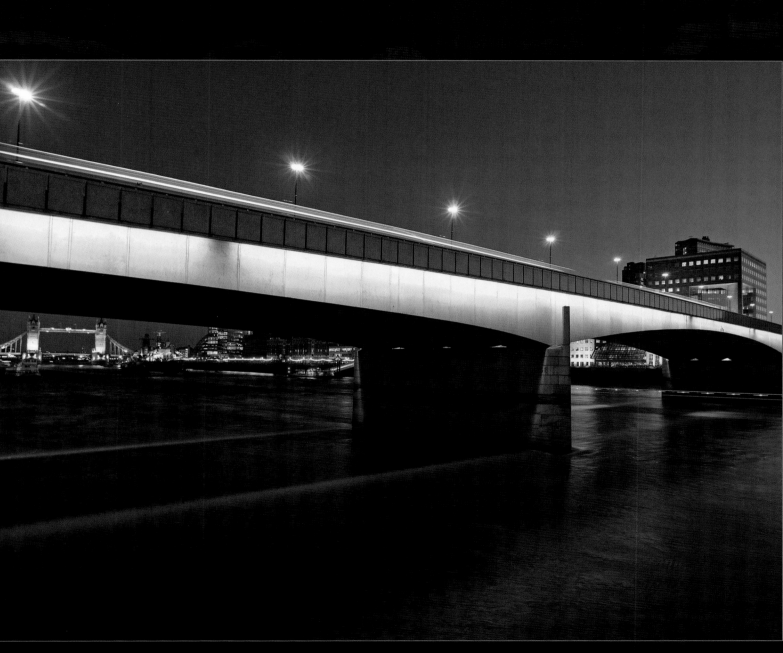

Merchants and tradesmen continued to build houses and shops on the bridge, which were often five or six storeys high, and the narrow roadway soon became rather like a tunnel between the buildings. In fact the bridge was so overcrowded, its population was deemed sufficiently large to have its own Alderman (community representative) and to become a ward of the city.

Despite its shortcomings the bridge lasted for over 600 years, the rent from houses built on it providing for its upkeep. Indeed the bridge accounts of 1385 record 138 business premises paying a total of £160 4s in rent. Thirty-four of these premises had a 'haut pas', which, at a minimum of three storeys high, joined the upper floors of houses on opposite sides of the street and effectively formed an archway. Poor maintenance and the occasional fire meant the number of houses and businesses in this little town on the bridge was always changing.

The bridge's arches were so narrow that today's pleasure boats would not have been able to navigate them. In fact the piers were so close together that they ended up dividing the tidal Thames from the upper river, holding back as much as 80% of the river's flow. As a result, water levels on either side of the bridge differed by as much as six feet and treacherous rapids formed between the piers. Not even the addition of two 'starlings' (breakwaters) protecting each pier could prevent the river roaring through the arches like a modern-day weir. To make matter worse, the arches were all different sizes making navigation even more hazardous. They were given names by the watermen such as Long Entry, Chapel Lock, Gut Lock, Rock Lock and Draw Lock.

Steering a boat between the piers or 'shooting the bridge', as it became known, 'was attempted by only the brave or the foolish'. Many tried and many drowned. The bridge was 'for wise men to pass over, and fools to pass under'. The poor watermen of course had no

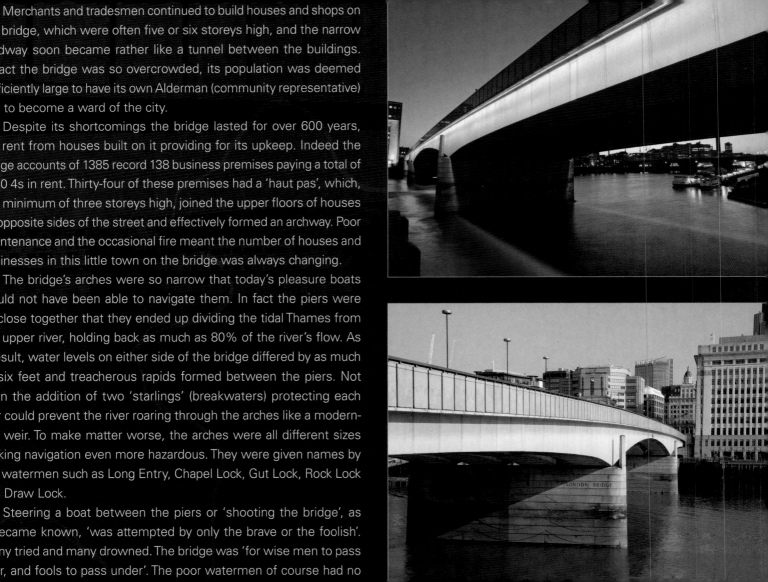

such choice and had to guide their boats through the rapids, though many were lost.

The Duke of Norfolk's fully loaded barge struck a starling and sank while shooting the bridge in 1428. The duke and two of his gentlemen clung to the starling and were saved, but the rest of the party were not so lucky. Indeed most travellers down the ages left their boat on one side of the bridge and walked across to the other to resume their journey, including, it is reported, Cardinal Wolsey on his regular river journeys from Hampton Court to see the King Henry VIII at Greenwich Palace. There was also the risk of being hit by rubbish hurled from the bridge, which was particularly unpleasant if the people living on it were emptying their latrines.

Some of the water flow through the bridge was channelled to turn large waterwheels below the arches. These were originally used only for milling grain, but, in 1582, part of the city was supplied with piped water when Peter Morris erected a series of waterwheels at the northern end of the bridge.

A gatehouse on the bridge, Drawbridge Tower became known for its gruesome display of severed heads. Having been dipped in tar to preserve them, the heads of traitors were then impaled on poles on the gate. This macabre display was subsequently moved to the Southwark Gate, the first head to appear on it being that of William Wallace in 1305. Thus began a custom that would continue for 373 years. Other famous heads impaled on the pikes were Jack Cade in 1450, Sir Thomas More in 1535 (his daughter, Margaret Roper, bribed a man to remove her father's head, and she came by boat during the night to take it away), Bishop John Fisher also in 1535 and Thomas Cromwell in 1540. A German visitor to London in 1598 is said to have counted more than thirty heads displayed on the bridge. The last head to be mounted on the Southwark Gate was believed to have been

William Stayley, a Roman Catholic, who was accused of being involved with Titus Oates in a popish plot in 1678.

In 1577 the northern gate was replaced by Nonesuch House, which had been built in Flanders and transported up the Thames by barge. It was an unusual building in that no nails had been used in its construction. It is thought that the house was used as a residence for the Lord Mayor of London.

London Bridge witnessed many more important historical events: Wat Tyler threatened to burn it down during the Peasants' Revolt in 1381, Henry V rode over it after his victory at the Battle of Agincourt in 1415, and Charles II rode across it to reclaim the throne after the restoration of the monarchy in 1660. Six years later the Great Fire of London would have destroyed the bridge had 43 houses and businesses at the northern end not already been damaged in 1633 after a bucket of ashes was left under a stairway, the gaps left by the earlier blaze preventing the great fire spreading. In fact the tightly packed houses on the bridge had always been a fire hazard and there had been a number of disasters, the first of which, in 1212, destroyed houses at the southern end.

In 1722 there was an attempt to organise and direct traffic on the bridge, the lord mayor decreeing that 'All carts, coaches and other carriages coming out of Southwark and going into the City do keep all along the west side of the said bridge: and all carts and coaches going out of the City do keep all along the east side of the said bridge.' In other words, keep to the left. It is possibly due to this decree that we started driving on the left in this country.

By 1763, all of the houses had been removed, and the bridge was then widened. The two centre arches were replaced with a longer single span in an attempt to improve navigation on the river. Problems arose however as the river's power was now concentrated at a single point

and it started to tear away the existing piers. This made the bridge unstable and a hazard to riverboats.

On 27 March 1782 the crossing was freed from toll.

The bridge was left in a dilapidated condition after its arches were damaged by severe frost in 1813 and 1814, and in 1821 parliament appointed a committee to determine what should be done with it. They recommended that a new bridge be built, and arranged a competition to consider various designs. George Dance, Ralph Dodd, John Rennie and Thomas Telford all submitted proposals. Thomas Telford's 600-foot single span cast-iron bridge was the most ambitious but there were fears over its stability and it was rejected.

Finally, in 1824, John Rennie's design was accepted. The contract though was given to his second son, also called John, as his father had died three years earlier on 4 October 1821. The new bridge was to be built very close to the old bridge, just 180 feet upstream in fact. For a short period of time Londoners were able to see both bridges side by side. John Garratt, the Lord Mayor of London, accompanied by the Duke of York, laid the foundation stone on 15 June 1825.

The new five-arch bridge was built from Dartmoor granite. It was 1,005 feet long and 56 feet wide and cost £680,232. The additional cost of building the approaches took the bill to over £2,000,000 however. King William IV and Queen Adelaide opened the bridge on 1 August 1831 in a ceremony of wondrous pomp and grandeur. The king and queen were rowed downstream to the bridge in a royal barge followed by a noisy flotilla of small boats. As they arrived, they were greeted with a cacophony of sound from church bells, military bands and cannon fire. They then joined the lord mayor and 1,500 guests for a lavish banquet. Having finished the bridge, his father's last great work, John Rennie was knighted, accepting an honour that his father had declined fourteen years earlier.

The old London Bridge was then demolished. Peter de Colechurch's bones were found in the remains of the chapel crypt and were then irreverently disposed of in the river. Why such little respect was shown for the man who built a bridge that stood for six hundred years is not known.

London Bridge Station was constructed just south of the bridge when the railways reached the capital. Thousands of daily commuters arriving at the station then walked across to the City and the bridge became increasingly busy. It was widened by 11'6" in 1902-04 when new granite brackets were inserted into its sides in an attempt to ease the ever-increasing traffic congestion. John Rennie's bridge was not destined to last as long as Peter de Colechurch's however. It became apparent that the new bridge was gradually sinking at the southern end, settling into the mud by an inch a year during its first eight years. And by the 1960s it was unable to cope with 20th century traffic.

The Corporation of London somewhat controversially sought an Act of Parliament allowing the bridge to be sold. The hope was that any money raised from the sale would go a long way towards paying for a new bridge. Much to their surprise the American-owned McCulloch Oil Company had their £1,000,000 bid accepted as The Corporation 'simply couldn't refuse' the offer.

Rennie's bridge was sold to Robert P McCulloch on 18 April 1968 for $2,460,000. The first stone was removed and lowered by Lord Mayor Sir Gilbert Inglefield in September 1968. Ten thousand tons of granite was then carefully shipped to Long Beach, California, from where it was transported by lorry to Lake Havasu City, Arizona. Each stone was marked with four numbers for shipping and rebuilding. The first denoted which span the stone had come from, the second, which row, and the last two numbers detailed its position in that row. During the dismantling process workers found that there were already code numbers on the stones. It seemed that Rennie had had the foresight to number the granite blocks as they left the quarries.

Astonishingly the bridge was allowed to enter the United States as a duty-free good, a 'large antique' of 10,246 pieces in fact. It was reconstructed at Lake Havasu City and was dedicated on 10 October 1971. The bridge now spans the canal flowing from Lake Havasu to Thompson Bay, and is the centrepiece of an English theme park. It has become one of Arizona's most popular tourist attractions after the Grand Canyon. A few remnants of Rennie's bridge stayed in London however. A granite arch and a narrow flight of stairs, known as 'Nancy's Steps' (from Charles Dickens's Oliver Twist), remain on the south bank. In Newcomen Street a George III coat of arms, which was on the Southwark Gate, can still be seen.

Designed by William Holford & Partners, the current London Bridge is a dull but practical construction consisting of three spans of pre-stressed concrete cantilevers. It is 860 feet long and 105 feet wide and was built in four pre-cast concrete sections in Surrey Docks before being brought upriver by barge. It was partially paid for by the sale of the earlier Rennie bridge, while the City of London's Bridge House Estates contributed the remaining £4,000,000. In 1984 HMS Jupiter hit the bridge damaging both the ship and the bridge parapet. Today London Bridge is one of the busiest bridges over the Thames.

London Bridge is falling down,
Falling down, falling down.
London Bridge is falling down,
My fair lady.

(Traditional nursery rhyme)

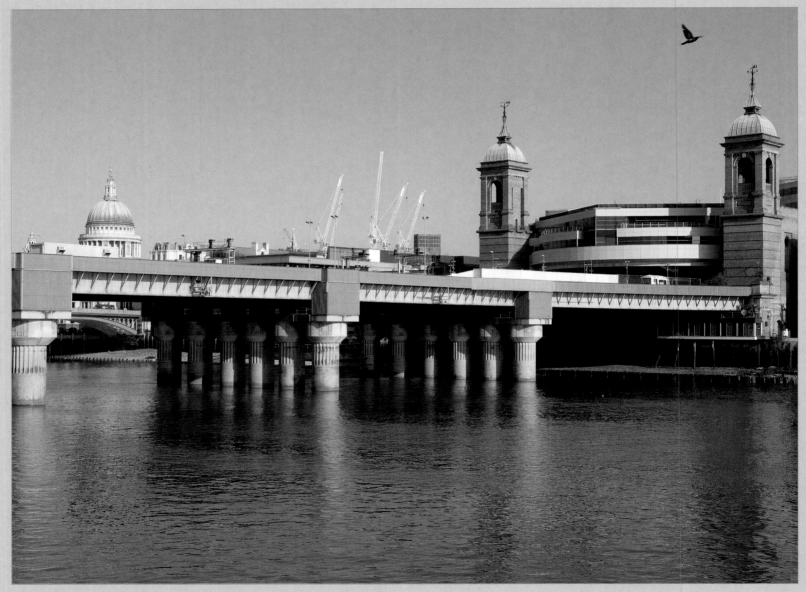

Cannon Street Railway Bridge

Taking trains to and from the city of London.

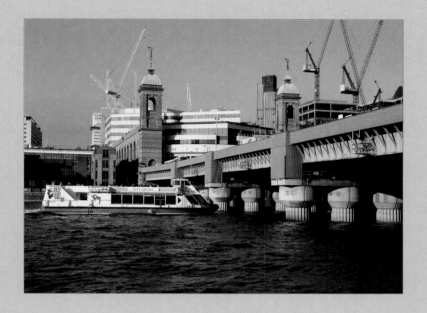

In a parliamentary act of 1861, South Eastern Railways were given the authority to build a railway station and river bridge at Cannon Street, within a mile of their original station at London Bridge. Sir John Hawkshaw, the railway company's consultant engineer, designed the station, the bridge and the approach viaducts. Work began in 1863 and both the station and bridge were opened on 1 September 1866 having cost £350,000.

The bridge was originally called the Alexandra Bridge in honour of the Danish princess who had married Edward, Prince of Wales, in 1863, but it soon became known as the Cannon Street Railway Bridge. The bridge had five arches supported by cast-iron Doric pillars and carried five railway lines. It also had two footpaths, one of which was accessible to the public for a ½d toll (this was abolished in 1877), while the other was reserved for railway employees only. In 1893 the bridge was widened and strengthened by adding four extra cast-iron cylinders to the upstream side of each pier (they also removed the footpaths).

In the last hundred years the bridge has been rebuilt twice. The station was badly damaged during the Second World War but was only fully repaired in the 1960s, and British Railways rebuilt it again in 1981. Today the bridge is 855 feet long with five wrought-iron plate girder spans set on cast-iron columns. It carries ten sets of rail tracks.

Southwark Bridge

The least used bridge in central London.

Southwark Bridge is a road bridge linking the City on the north bank of the Thames with Southwark in the south. It was designed by Basil Mott and Sir Ernest George and was opened in 1921. The bridge has five arches, is 800 feet long and 55 feet wide. The arches and piers are directly aligned with those on Blackfriars Bridge to ease the river's flow and reduce potential cross currents. The bridge is used by an average of 17,000 vehicles a day – the lowest number of vehicles using any of central London's bridges – and is owned and maintained by Bridge House Estates.

John Rennie designed the first Southwark Bridge, the second of his three bridges across the Thames. It was built to provide an alternative crossing to London Bridge at a time when the latter was heavily congested. Rennie was always meticulous with his choice of stone, and in this instance dispatched his son to the granite quarries in Aberdeen. But John junior was unable to find large enough blocks there and the stone eventually came from a Peterhead quarry.

During construction 13 workmen drowned after they jumped into a boat intending to ferry them ashore at the end of their day's work. The boat crashed into a barge and capsized shortly afterwards.

The bridge was opened at midnight (to publicise its new style of lighting) on 24 March 1819, five years after building work had started. There were no celebrations though because the cost of the bridge had risen by 25% during construction and the Southwark Bridge Company was therefore struggling financially. Indeed John Rennie had to sue the company for payment.

The 708-foot, triple-span cast-iron bridge with granite piers included one of the longest (240 feet) and most attractive cast-iron arches ever built; in fact it was the largest cast-iron construction of that era. Unfortunately, however, the bridge was not a success. Toll returns didn't match the company's expectations and the bridge was too narrow. It also wasn't strong enough to carry heavy goods vehicles and the approaches were inadequate, while a steeply humped roadway in the centre of the bridge didn't help traffic either. The financial position of the Southwark Bridge Company continued to decline as a result, and Bridge House Estates eventually bought the bridge from the beleaguered outfit for £200,000 in 1866. The toll charges were removed in 1868, which helped to increase the volume of traffic, but the bridge was still under used.

In 1911 Bridge House Estates decided that a new crossing was needed and they started to demolish the old bridge two years later. Basil Mott, of Mott, Hay & Anderson, with Sir Ernest George as architect, designed a new steel bridge with five arches. Work on the bridge was held up because of material shortages due to World War I, but it was finally opened by George V and Queen Mary on 6 June 1921.

The new bridge had cost £375,000, which was funded entirely by Bridge House Estates. It is a delightful, wide elegant bridge, which always gives the impression of being spacious, probably because it is little used by pedestrians. The most eye catching and charming features of Southwark Bridge, which is painted green and yellow, are the sentry-box-like structures on the turreted pier headings.

Southwark Bridge was the scene of one of the worst disasters on the Thames. On the evening of 20 August 1989 the dredger *Bowbelle* crashed into the pleasure boat *Marchioness*. Fifty-one people lost their lives.

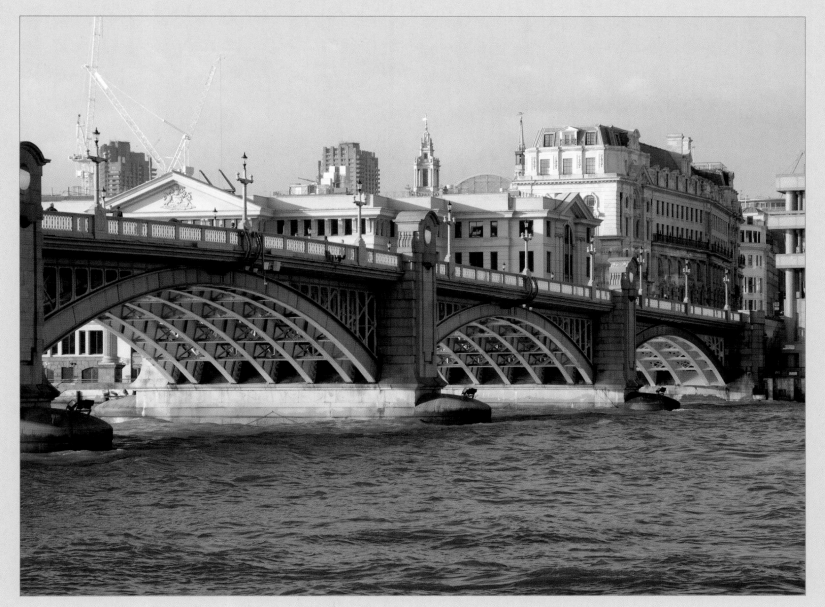

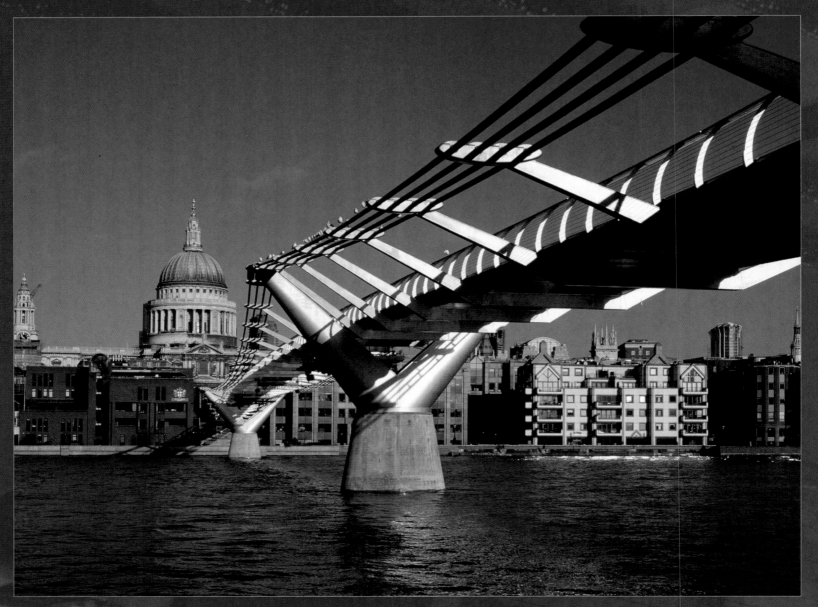

The Millennium Bridge

'A blade of light.'

This footbridge commemorating the millennium is London's newest. In fact it is the first new crossing to be built across the Thames in central London since Tower Bridge in 1894, and it too is owned and maintained by Bridge House Estates. The bridge links St Paul's Cathedral on the north bank to the Tate Modern art gallery at Bankside in the south. The alignment of the bridge gives the most spectacular view of the south facade of St Paul's from the other side of the river. The aluminium-decked bridge is 1,066 feet long and 15 feet wide. The walk across the bridge should be taken by every visitor to the capital, no matter how short his or her stay may be.

In 1996 Southwark Council ran an international competition to design a footbridge celebrating the forthcoming millennium, for which there were 227 entries. The winning entry was submitted by a consortium of Ove Arup (engineers), Foster & Partners (architects), and Sir Anthony Caro (sculptor). They described their submission as a 'blade of light' and helped raise the £16,000,000 required to build the bridge. Construction began in 1998, the main work, by Monberg Thorsen and McAlpine, beginning in April 1999.

To achieve the best possible view, as well as complying with height restrictions, the supporting cables suspending the bridge are below the deck level, which gives the structure a very low slung appearance. The bridge uses eight of these suspension cables, which pull against piers set into the riverbank with a force of 2,000 tons. The bridge is therefore capable of supporting 5,000 people at any one time. The bridge was dedicated by HM Queen Elizabeth II in a ceremony on 9 May 2000 and opened on 10 June. It was two months late and £2,200,000 over budget.

The bridge was closed just two days later for essential modifications. The organisers had invited many charities, including Save the Children, to the ceremony, but they severely underestimated the number of people who turned up. In fact 90,000 crossed the bridge on its first day, with up to 2,000 people on it at a time. Although there was never any danger to the public, the sheer volume of pedestrians caused unexpected lateral vibrations, which, in turn, started a swaying motion, earning the bridge the nickname 'Wobbly'. The problem was fixed by retrofitting dampers, which cost an additional £5,000,000, to control the bridge's vertical movement. It was eventually re-opened on 22 February 2002. When you approach the bridge from the river in the distance it has a fragile appearance (just a strip over the river) with the people crossing the bridge resembling 'Lowry-like figures'.

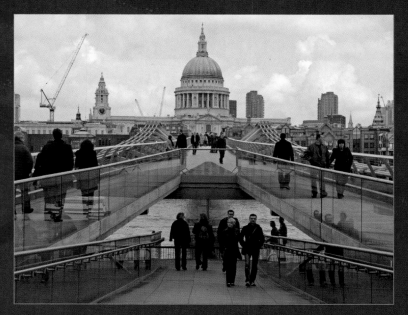

Blackfriars Railway Bridge
The original bridge's ornate red columns remain in the river.

Joseph Cubitt designed the second Blackfriars road bridge and the first Blackfriars rail bridge at the same time. The latter was needed to extend the London, Chatham & Dover Railway Company's line between Beckenham and Ludgate Hill. The wrought-iron bridge with lattice-girder spans set on masonry abutments and composite piers was opened at the same time as the station – which was originally called St Paul's – in 1864. Because the bridge was an integral part of the station, it boasted the most beautiful cast-iron decorative work, including large painted shields adorned with the railway company's crest.

The bridge was designed to carry four sets of railway tracks, but after only a few years it became unable to cope with an increase in the number of trains. So another railway bridge, designed by W Mills (the London, Chatham & Dover Railway Company engineer) and assisted by John Wolfe Barry and Henri Marc Brunel, was built just downstream from the first. Opened in 1886, the new five-span bridge, consisting of wrought-iron arched ribs, was 933 feet long and carried seven railway tracks.

London's railway system was restructured in 1923 and the number of trains using Victoria and Waterloo increased dramatically. Rail traffic into St Paul's never approached expected levels however. St Paul's Station was renamed Blackfriars in 1937, but it was still only used by a relatively small number of trains.

By the middle of the 20th century the first bridge was thought to be too weak to carry the weight of modern trains and Cubitt's original crossing was dismantled in 1984. The magnificent ornate Romanesque columns were left however and they remain in the river to this day.

One of the cast-iron crests of the London, Chatham & Dover Railway can still be seen near the south bank. Today Thameslink uses both the bridge and the station.

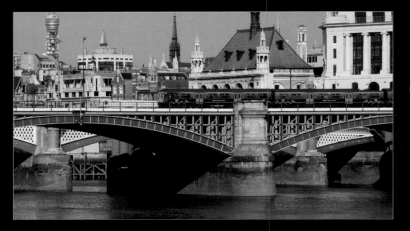

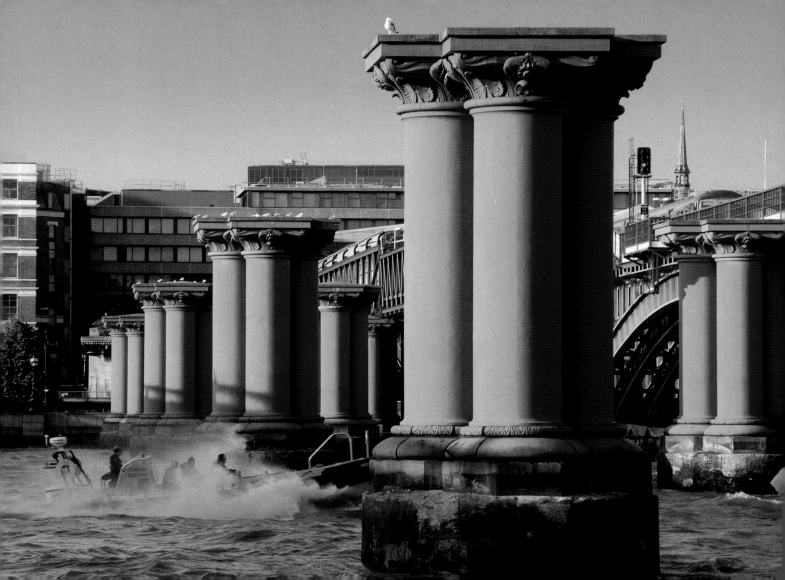

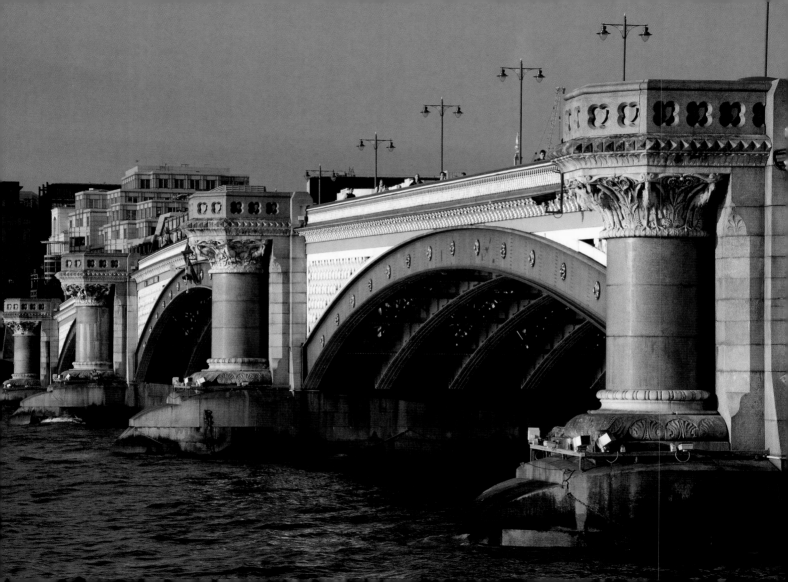

Blackfriars Bridge

Offers a magnificent view of St Paul's.

When the City of London Corporation was considering the future of London Bridge in 1753, they decided to build a bridge at Blackfriars. It would be 'a magnificent new entrance to the City' and would be only the third bridge in the centre of London after London and Westminster Bridges. As always seemed to be the case, the objections of the watermen had first to be addressed. They managed to negotiate a £12,500 payout before parliament would grant the Act authorising the bridge.

As usual, a competition was held to try and find the best design. It was won by Robert Mylne, a young Scotsman, whose entry beat those of both John Gwynn and George Dance. He envisaged an elegant bridge with nine semi-elliptical arches of Portland stone supported by double Ionic columns. The centre arch was to be 100 feet wide while the others were 93 feet.

Lord Mayor Sir Thomas Chitty laid the first stone on 31 October 1760, and the bridge was opened to the public nine years later on 19 November 1769. It was 995 feet long, 42 feet wide and cost £152,840. It was a beautiful, classical bridge, which, with St Paul's Cathedral in the background, became the subject of a number of 18th century oil paintings, of which William Marlow's in the year of completion is particularly stunning.

Originally known as William Pitt Bridge (after the prime minister), it was soon changed to Blackfriars when Pitt became less popular. The Blackfriars name came from the 13th century Dominican monastery, which had once stood nearby.

Tolls were charged to try and recover some of the building costs but

during the Gordon riots of July 1780 the tollgates were destroyed and the money stolen. The charges were eventually dropped in 1811.

The bridge had other problems too. Polluted water had been flowing out of the nearby River Fleet and into the Thames for hundreds of years, and by the early 1800s its mouth had become an open sewer. This eroded the bridge masonry, which had deteriorated so far by 1833 that engineers Walker and Burgess were called in to try and repair the damage. Between then and 1840 they had little success and the Court of Common Council decided that the bridge should be replaced.

Robert Mylne's bridge was demolished in 1860, though a temporary structure was quickly erected in its place. At the same time, the London Chatham & Dover Railway Company applied to build a bridge alongside it to take the extended railway line into the new station at St Paul's. Joseph Cubitt was given the task of building the bridges. The road bridge required five elliptical wrought-iron arches (the first bridge to use this design) so as not to create cross-currents and disrupt river traffic. Massive granite piers topped with pulpits and granite seats in each pier-head supported the arches. Open to both road traffic and pedestrians, the bridge stands between Waterloo Bridge to the west and Blackfriars Railway Bridge to the east. It links the Inns of Court and Temple Church to the north of the river, with the Oxo Tower and the Tate Modern in the south.

By driving over it from the Surrey bank, HM Queen Victoria opened the £320,000 road bridge on 6 November 1869. (She then went on to open the new Holborn Viaduct on the same day.) The bridge was 963 feet long – of which 185 feet was the centre span – and 75 feet wide. It was widened to 105 feet between 1907 and 1910 so that trams could also use the bridge.

The bridge was thrust into the media spotlight after the hanging of Roberto Calvi in 1982. Known as 'God's banker' because of his

connections with the Vatican, Calvi was chairman of the Banco Ambrosiano. He had fled Italy when he thought the bank was about to collapse. He was then found strangled but his body had been arranged to look as though he had taken his own life. Police initially recorded his death as suicide but his family became suspicious when they learned that he had £15,000 in cash on his body, and that his pockets were full of bricks. Mafia turncoats later told Italian prosecutors that the mob had arranged for Calvi to be murdered because he had bungled

a £150,000,000 money-laundering operation.

This is another of the bridges owned and maintained by Bridge House Estates and is used by approximately 54,000 vehicles a day. It is now the widest road bridge over the Thames in London. The metalwork is painted bright red, white and gold, with the emblems fixed into the supports also in gold. Robert Mylne's original bridge design can still be seen on the walls of the southern pedestrian subway under the bridge itself.

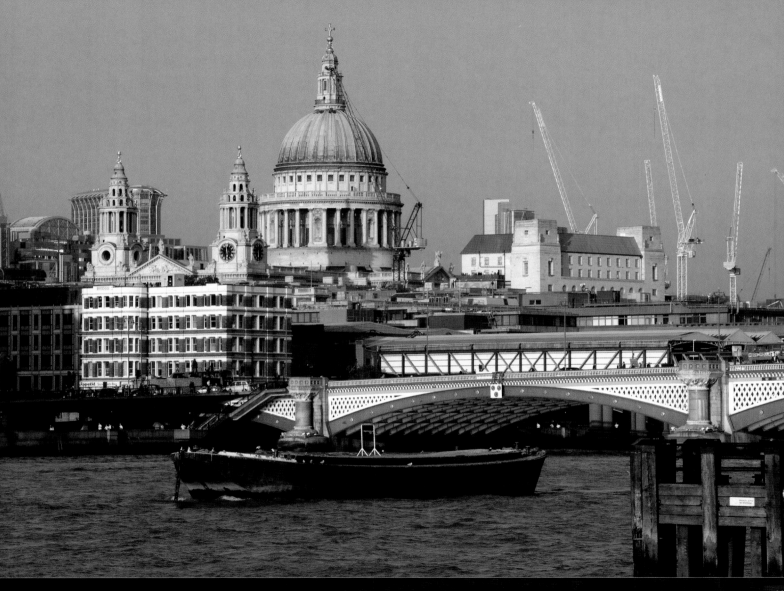

Waterloo Bridge
The Ladies' Bridge.

This bridge spans the Thames at the long bend known as King's Reach. It offers stunning views of the city, with St Paul's in the east, and the Embankment, Hungerford and Golden Jubilee Bridges, as well as the London Eye and the Houses of Parliament, in the west. To the north, Somerset House, the Strand and Aldwych line the river, while the South Bank, with its Queen Elizabeth Hall, National Theatre, Royal Festival Hall and Waterloo Station, lie opposite. The bridge links The Strand with the South Bank and Waterloo Station. Numerous pleasure boats can be found loading and unloading below.

By the beginning of the 19th century the population of London was already over a million and both Blackfriars and Westminster bridges were struggling to cope with the resulting increase in traffic. A parliamentary act of 1809 gave the Strand Bridge Company, the largest and most successful of all of the toll bridge-builders, the authority to raise £500,000 (in £100 shares) to fund a new bridge.

Sir John Rennie designed the first Waterloo Bridge and it was built between 1811 and 1817. The building work generated huge public interest and drew crowds on most days. Tsar Alexander I of Russia visited the site on his 1814 trip to London.

The 2,346-foot long and 27-foot wide structure was supported by nine elliptical arches of Cornish granite, with two Grecian Doric columns on each pier. It was, according to George Birch in The Descriptive Album of London (c.1896), 'considered to be the finest stone bridge in the world'.

It was originally called the Strand Bridge but was renamed Waterloo Bridge in 1816, the year after the Battle of Waterloo. It was opened on 18 June 1817 by the Prince of Wales. The Duke of Wellington accompanied him, as it was the second anniversary of the battle. Their guard of honour included some soldiers riding the same horses they had in the battle. The Prince of Wales was so delighted with the new bridge that he asked to bestow a knighthood on John Rennie on the spot, though Rennie politely refused his request.

Originally opened with a ½d toll for foot passengers, the bridge was bought by the Metropolitan Board of Works in 1878 for £474,200, then the largest sum paid for a single bridge. The Prince and Princess of Wales freed it from toll on 5 October the same year.

By the mid-1880s it became apparent that the bridge's foundations were in need of repair. This was almost certainly because the Old London Bridge with its 20 arches had been removed. This had the effect of dramatically increasing tidal scour which undermined bridge foundations. (By a strange quirk of fate it was John Rennie's son who dismantled the Old London Bridge having built the New London Bridge designed by his father.) All of Waterloo Bridge's piers were reinforced between 1882 and 1884 but it wasn't a long-term solution. In 1923 further attempts were made to save the ailing bridge, but it was to no avail and the bridge was closed on 11 May 1924.

There was pressure from conservationists to repair the bridge, but the London County Council commissioned Sir Giles Gilbert Scott, who designed Battersea Power Station, to design a new bridge. Peter Lind & Company won the building contract and work began in 1937. The foundation stone was not laid until 4 May 1939 however. It was cut from stone from the old bridge, and a small copper time capsule containing newspapers of the day, newly minted coins and postage stamps was placed in a cavity underneath.

With the outbreak of the Second World War came a shortage of male labour. Construction was delayed at first, but because building

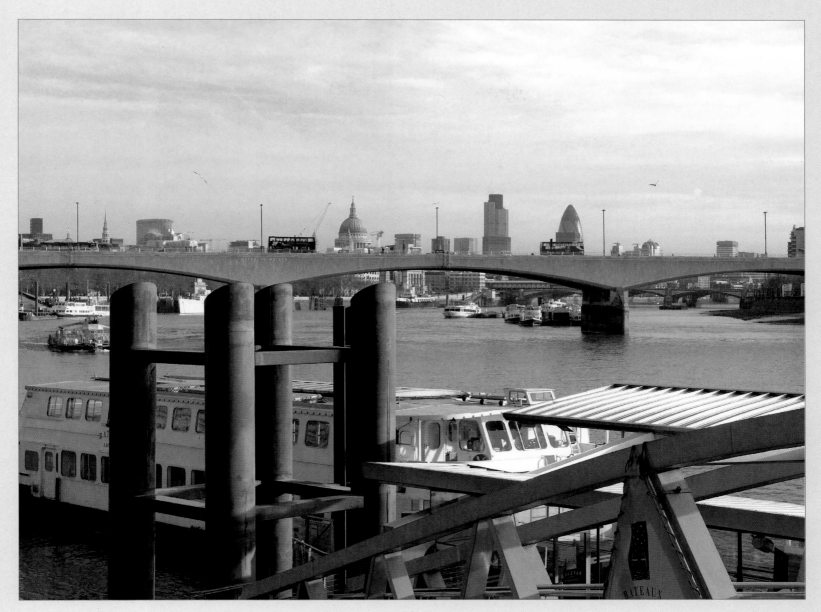

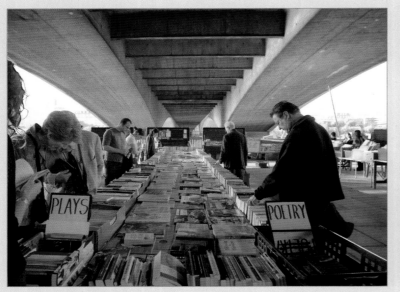

the new bridge was seen as a priority, women were employed to carry out much of the work, and it quickly became known as the Ladies' Bridge.

It was damaged by German bombers on several occasions, indeed it was the only bridge to suffer multiple hits, but it was eventually re-opened to two lanes of pedestrian and road traffic by Ealing steel worker Charlie Barnard in 1942. It wasn't finally finished until 1945 at a cost of £997,057 when it was formally opened on 10 December by Rt. Hon Herbert Morrison.

The bridge has five arches, reinforced concrete beams (the first Thames bridge to incorporate the technique) and is faced with Portland Stone. It was also the first to boast electric lights. Two of John Rennie's original Doric columns are preserved in the southern abutment. At 1,230 feet long and 80 feet wide it is the longest bridge in London.

The two Waterloo bridges have been popular with artists. Claude Monet and John Constable (who was present at the opening ceremony) both painted the first bridge. The current bridge has featured in songs, such as *Waterloo Sunset,* and films, such as *Waterloo Bridge.* But the bridge also has a dark side. A large number of suicides are recorded here each year. It was also where the KGB murdered the Bulgarian dissident Georgi Markov in 1978, an assassin firing a pellet containing the poison ricin into Markov's leg from the tip of an umbrella.

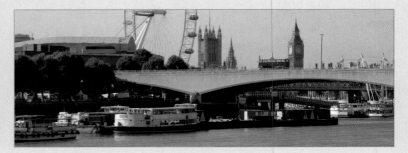

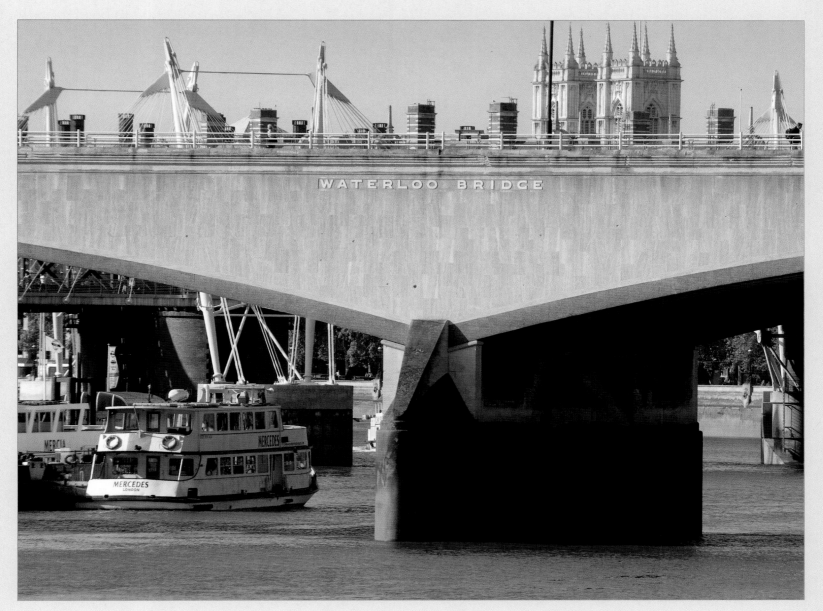

John Constable 1776-1837

Throughout history many famous artists including Constable who was fascinated by the bridge have painted Waterloo Bridge. Constable was born on 11 June 1776 in East Bergolt, Suffolk. He was the fourth child of Golding Constable, a wealthy corn merchant who owned 90 acres of land and two water mills at Flatford and Dedham. After going to school in Lavenham and Dedham, John worked briefly in the family business, but he always wanted to be an artist. (As a boy he'd painted the fields and landscapes around his home.)

In 1799 he attended the Royal Academy School, where he met Turner (who was a year older than him). He exhibited his first landscape paintings in 1802. Although his parents were concerned about his desire to be an artist they didn't stop him, but as late as 1809 they were still worried about his financial situation. They encouraged him to concentrate on portrait painting instead, which would provide him with a more regular income. In fact at the time his mother wrote, 'Dear John, how much do I wish your profession proved more lucrative. When will

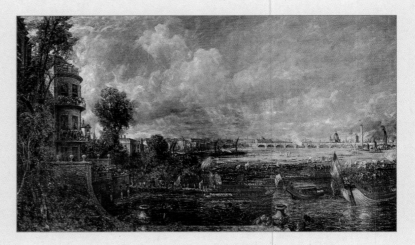

The Opening of Waterloo Bridge, 1832

the time come for you to realise?'

In 1821 Constable moved to Hampstead Heath in London with his wife Maria, who he'd married in 1816. Throughout the summer of 1821 he produced a unique collection of cloud compositions painted on Hampstead Heath. In a letter to his friend John Fisher, Constable wrote, 'skies must and always shall with me make an effectual part of the composition… the sky is the source of light in nature – and governs everything'. Certainly his approach to landscape painting depended on watching the clouds and effects of the light.

Maria died from tuberculosis and pleurisy in 1828, which brought to an end Constable's most prolific period. From then on he became increasingly dark, brooding

and melancholy. Unlike Turner, Constable sold only 20 paintings in England during his lifetime and he never became rich and famous. He was also not admitted to the Royal Academy until he was 52, only eight years before his death. In fact his works were appreciated much more in France. 'The Hay Wain', probably his most famous painting, failed to find a buyer when on display at the Royal Academy's 1821 exhibition. When it was unveiled at the Paris Salon of 1824 it caused a sensation however and Charles X awarded it a Gold Medal.

In France Constable was much influenced by the French artist Delacroix, and the 'Barbizon School', who followed Constable's lead in working outdoors, observing and interpreting nature – a theme later picked up and developed by the Impressionists.

Constable painted
Waterloo Bridge from Whitehall Stairs	1817
Richmond Bridge	1818
Waterloo Bridge from Whitehall Stairs	1819
The Opening of Waterloo Bridge	1829
The Opening of Waterloo Bridge	1832

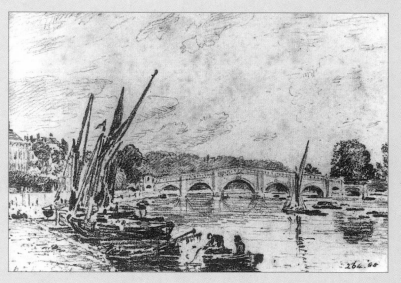

Richmond Bridge, 1818

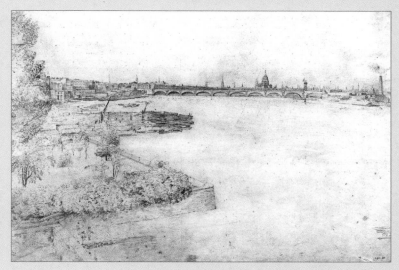

Waterloo Bridge from Whitehall Stairs, 1817

Hungerford and Golden Jubilee Bridges

Taking commuter trains in and out of Charing Cross.
The last bridges to be built over the Thames in central London..

Hungerford Bridge is made up of three separate bridges positioned side by side across the Thames between Waterloo Bridge downstream and Westminster Bridge slightly upstream. At the north end of the bridges is Charing Cross railway station, the Embankment tube station and the Victoria Embankment. On the south bank are the Royal Festival Hall, the London Eye and Waterloo Station.

The group consists of a railway bridge, which is sometimes called Charing Cross Bridge, and the Golden Jubilee Bridges (two footbridges on either side of the railway bridge that use its foundation piers). Collectively the bridges are known as Hungerford Bridge.

The first of these (the Charing Cross Bridge) was designed by Isambard Kingdom Brunel to be an elegant suspension footbridge. With a central span of 670 feet it was then the longest suspension bridge in Britain. The Hungerford Market Company funded the build in an attempt to attract business from the south bank. The market, which had been started by Sir Edward Hungerford in 1682, was situated where Charing Cross Station stands today and the bridge was named after him. It opened as a toll bridge in 1845 and on its first day more than 80,000 people paid ½d each to cross.

In 1859 the South Eastern Railway Company, who wanted to extend their line from London Bridge through to the newly proposed Charing Cross Station, bought the bridge. And in 1864 they replaced Brunel's suspension bridge with a new railway crossing. (The chains from the old bridge were sold for £5,000 and were re-used by Brunel in the Clifton Suspension Bridge over the Avon Gorge at Bristol.)

Designed by Sir John Hawkshaw, the new bridge was 1,200 feet long. It was constructed from nine wrought-iron girders set on cast-iron cylinders along with two brick piers from the original bridge. In 1886 the bridge was widened to accommodate an increase in the number of railway tracks from four to eight. Pedestrian walkways were then added to each side of Hawkshaw's bridge, but when the railway bridge needed to be widened again the upstream walkway was removed. The remaining footbridge was narrow, poorly maintained and potentially dangerous to cross at night. It was the scene of a particularly brutal murder in 1999.

In 1996 a competition was held to design the replacement for the remaining footbridge. New pedestrian bridges on either side of the existing railway bridge would commemorate the 50th anniversary of the Queen's coronation. Architects Lifschutz Davidson Design won the competition and they, with the engineering firm WSP Group, went ahead with twin cabled-stayed 15-foot-wide footbridges that were opened in 2002. These two delightful bridges, which have won awards for construction, design and lighting, have brightened up the rather dreary riverside considerably. And building the two new bridges had the added benefit of strengthening the existing railway bridge.

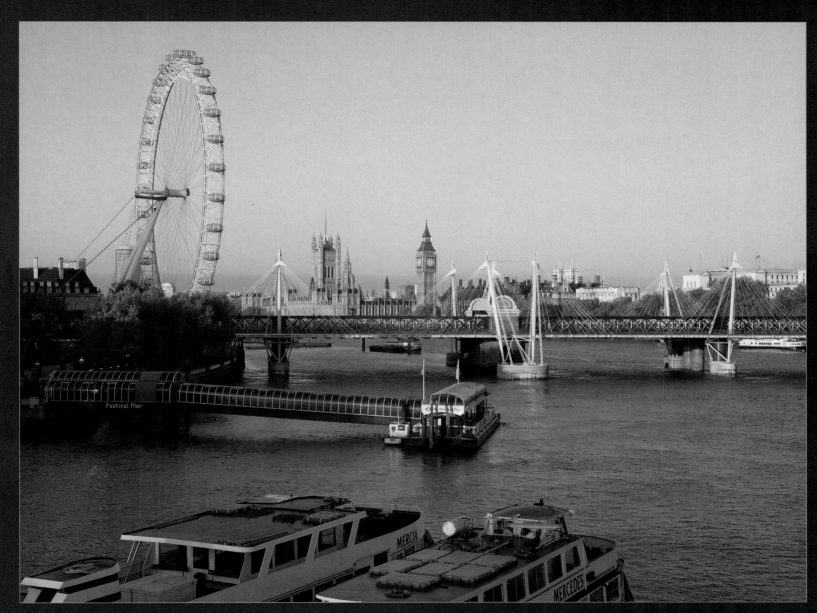

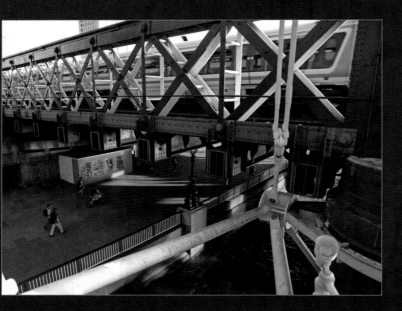

Claude Oscar Monet 1840 – 1926

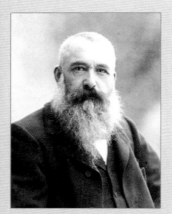

Charing Cross Bridge was painted many times by Claude Monet who delighted in the hazy grey skies and fogs that were commonplace in 19th Century London.

Claude Monet was born on 14 November 1840 in Paris. He moved with his family to the port of Le Harvre, where the river Seine joins the sea, when he was five. Both his parents and teachers found him to be unruly, ill disciplined, and unlikely to make a success of his life. His father had wanted him to join the family grocery business but Monet always wanted to be an artist.

He soon became known for his excellent charcoal caricatures, which he could sell for between 10 and 20 francs each. He spent his youth on the Normandy beaches where he met the artist Eugene Boudin, who became his mentor, taught him how to use oil paints, and how to paint outdoors.

In 1859 Monet returned to Paris to study at the Atelier Suisse, where he became friendly with Pissaro. He served in the French army in Algeria from 1860 to 1862, before joining the Charles Gleyre studio in Paris where he met

Renoir, Sisley and Bazille. Later they would become known as 'The Impressionists'.

At the time of the Franco-Prussian War in 1870, Monet went to England to escape the fighting. It was then that he first studied the works of Constable and Turner. Monet painted the Thames and some of London's parks, before returning to France in 1872. Between 1883 and 1908 he travelled extensively around the Mediterranean painting many beautiful landscapes.

In 1899 Monet stayed in the Savoy Hotel, taking a room on the sixth floor, just as Whistler had done three years earlier, to paint scenes of the bridges and the Thames from the hotel window. He returned to the same room in the winters of 1900 and 1901.

Monet admired Whistler's *Nocturnes* for 'their uncanny power to evoke the mystery of early evening light on the Thames'. Pollution was so bad in London at the turn of century that the middle of the day often seemed like early evening. Monet loved the mists and smog though, telling his dealer, 'I adore London… But what I like more than anything is the fog.' He said he was terrified of waking up one morning to find that there was no fog and 'not even the least trace of mist'.

While at the Savoy, Monet painted a huge number of variations of Waterloo Bridge, Charing Cross Bridge and the Houses of Parliament with Westminster Bridge. He painted at all times of the day, both when there was

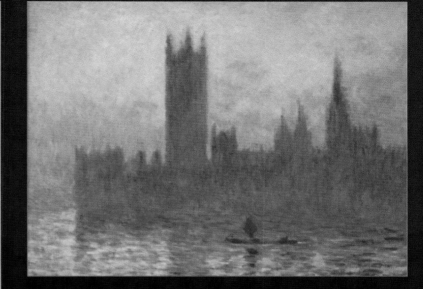

The Houses of Parliament, Sunset, 1904

smog and when it was clear, capturing the most incredible visual effects during varying atmospheric conditions. Indeed, he seemed inspired by the often dank weather conditions.

Monet developed pleurisy on his last visit to London in 1901 and took his last paintings of the Thames back to his studio in Giverny to finish. Towards the end of his life he had problems with failing eyesight caused by cataracts forming on both eyes. In 1926, the year of his death, he said, 'I have always had a horror of theories; my only virtue is to have painted directly in front of nature,

while trying to depict the impressions made on me by the most fleeting effects'. He died on 5 December 1926 and was buried in the churchyard at Giverny.

In 2004 Monet's *London, the Parliament, Effects of Sun in the Fog* sold for more than US$20 million. In 2007 his *Waterloo Bridge, Sunlight Effect,* which he painted in 1904 while staying at the Savoy, was sold at auction by Christie's for £17.9 million.

'I would like to paint as the bird sings'
Claude Oscar Monet

Monet painted

The Thames and the Houses of Parliament	1870
The Thames below Westminster	1871
Charing Cross Bridge, Overcast Day	1900
Waterloo Bridge, London	1900
Charing Cross Bridge	1901
Waterloo Bridge	1901
The Houses of Parliament	1901
Waterloo Bridge: Effect of Sunlight in the Fog	1903
Charing Cross Bridge, the Thames	1903
Charing Cross Bridge, Fog on the Thames	1903
Waterloo Bridge	1903
Waterloo Bridge, Sunlight Effect	1904
Houses of Parliament, Sunset	1904

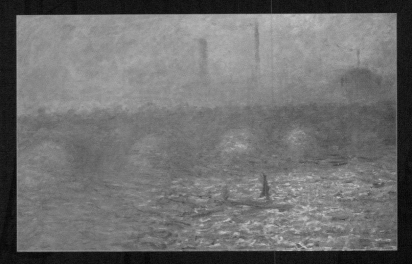

Waterloo Bridge, 1900

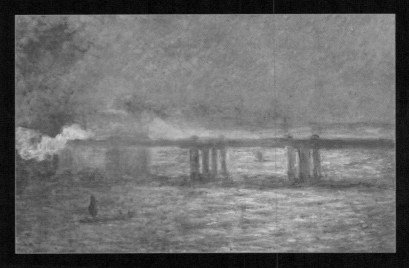

Charing Cross Bridge, painted 1901, signed 1903

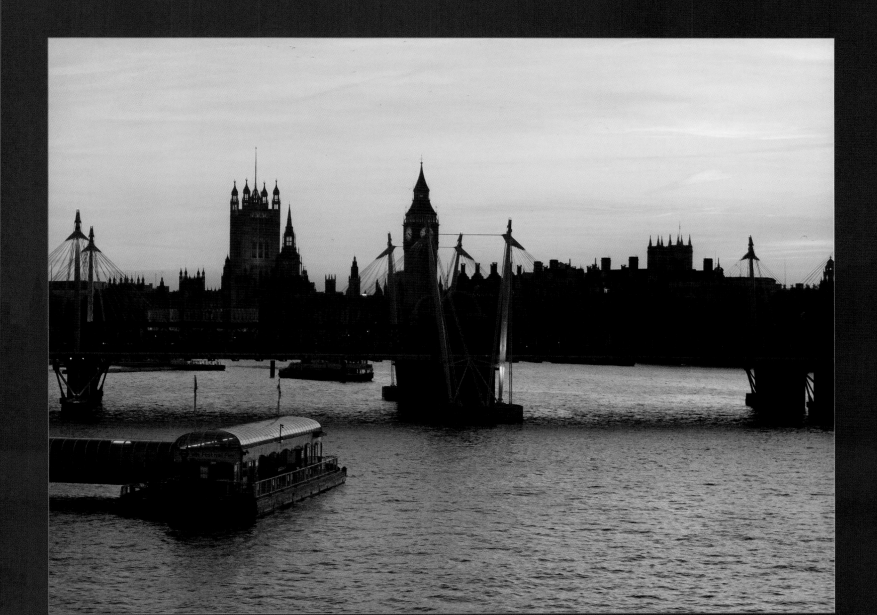

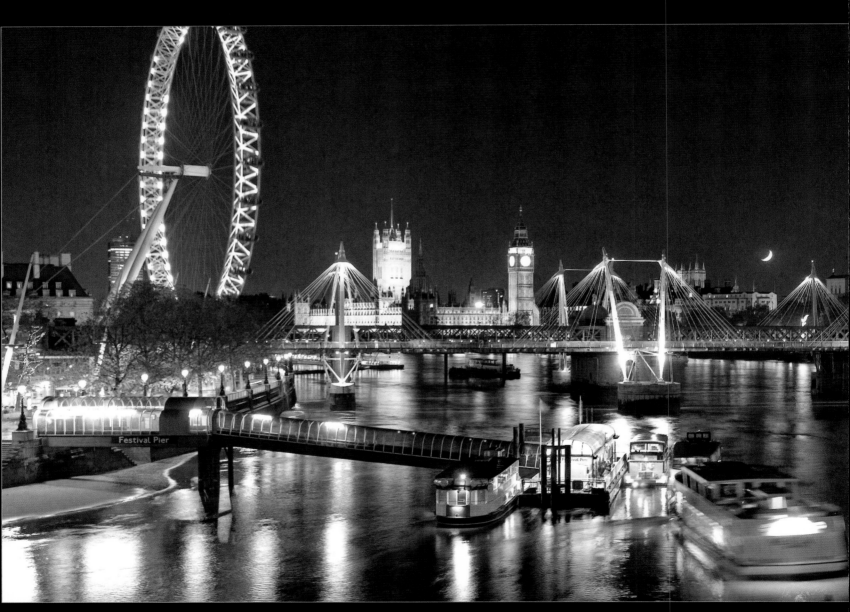

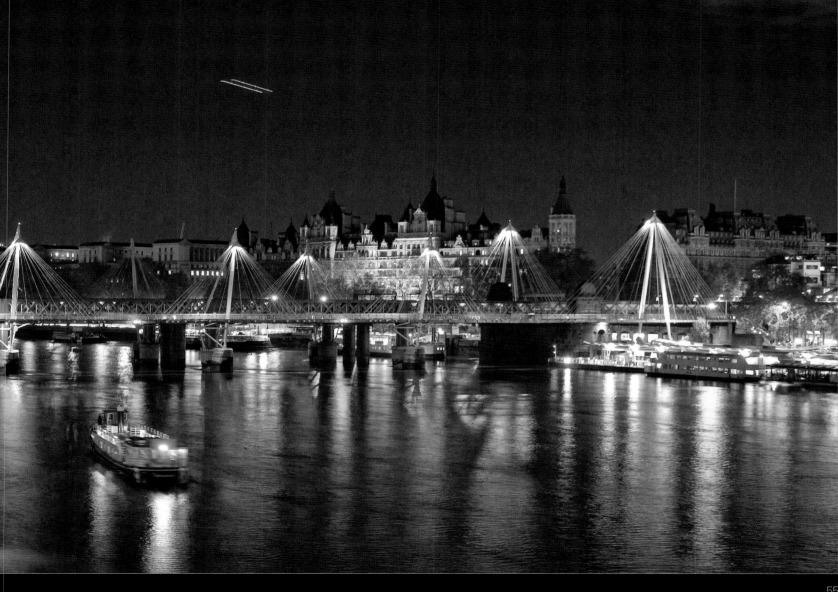

Westminster Bridge

The oldest bridge currently in use in central London.

Westminster Bridge is a road traffic and pedestrian bridge linking Westminster in the north and Lambeth in the south. Opened in 1862, the present bridge is the second on this site. A portcullis, the cross of St George, a thistle, a shield and a rose – the symbols of parliament and the United Kingdom – are resplendent in the bridge's ironwork.

Work on the first bridge began in 1736 and it was finally completed in 1750, this despite a debate that had simmered for more than a hundred years about bridging the Thames at Westminster. As there had been at Putney some years previously, there was a ferocious dispute at Westminster with the watermen, the church and the City of London Corporation (the three parties all fearing they would lose money, trade and influence) strongly opposed to the plans. The watermen could lose their livelihoods; the church, through the Archbishop of Canterbury, saw a potential loss of income from the church-owned horse-ferry; and the City Corporation was concerned about a decline in trade in the City and the London Bridge areas. It was a strange but powerful alliance.

Finally on 20 May 1736 the Earl of Pembroke and his Company of Gentlemen secured an Act of Parliament for: 'The Building of a Bridge across the River Thames from New Palace Yard in the City of Westminster to the opposite shore in the County of Surrey'. Compensation had to be paid to the archbishop and the people who ran the Lambeth horse-ferry, and to the watermen who operated a Sunday ferry.

The bridge was to be funded by a lottery, but the lottery was poorly run, not very popular and did not produce sufficient capital. Parliament had to be asked to save the bridge with a grant, which they eventually if reluctantly did.

Charles Labelye was appointed bridge engineer, while James King and John Barnard were appointed carpenters. Andrews Jelfe and Samuel Tuffnell were given the contract for the centre arch piers. The Earl of Pembroke laid the first pier's foundation stone at the end of January 1739. It was to be the first stone bridge over the Thames in London for over five hundred years. It took nearly twelve years to build and was fraught with technical difficulties. Nevertheless at half past midnight on Sunday 18 November 1750, accompanied by a crash of cannon fire, loud music from military bands and guns blazing, the lord mayor walked to the centre of the bridge. There were speeches and the singing of God Save the King at the ceremony before the mayor finally declared the bridge open.

The Earl of Pembroke, who had done so much to get the bridge built, had died earlier in the year and didn't see it opened however. Sadly this was not the first time this had happened: Peter de Colechurch didn't see his London Bridge finished, John Rennie designed the new London Bridge but died before it was built (it was later finished by his son John), and Sir Horace Jones never saw the completed Tower Bridge.

The bridge proved to be popular with artists and was painted a number of times, particularly by Canaletto (between 1746 and 1756) and Monet (between 1899 and 1904). Undoubtedly the most expressive of all the works, however, is J M W Turner's painting of the fire at the Palace of Westminster in 1834, which shows Westminster Bridge engulfed in flames (Turner himself was present at the scene of the fire). Also Wordsworth wrote his famous poem *Earth has not anything to show more fair,* from the bridge on 3 September 1802.

The bridge was 1,038 feet long and 44 feet wide. It was built from white Portland and pale green Purbeck stone, and had 15 arches built

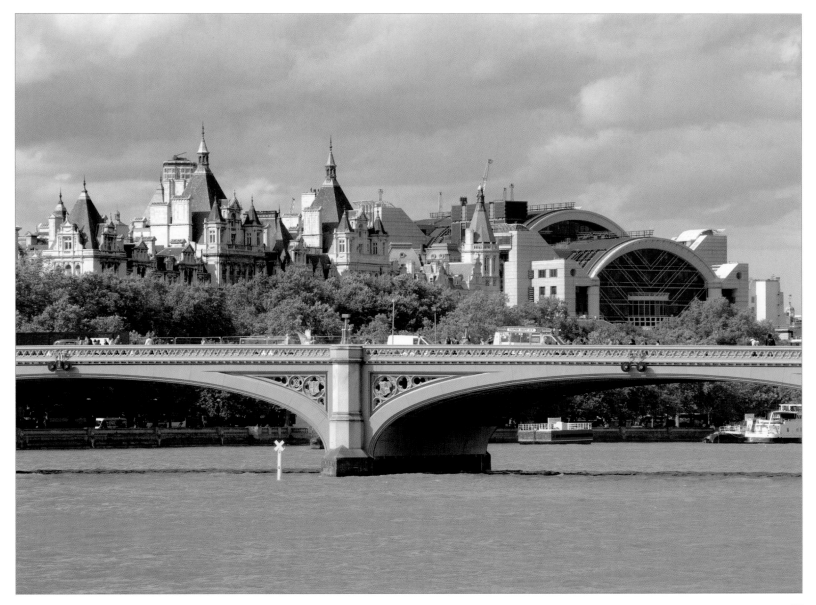

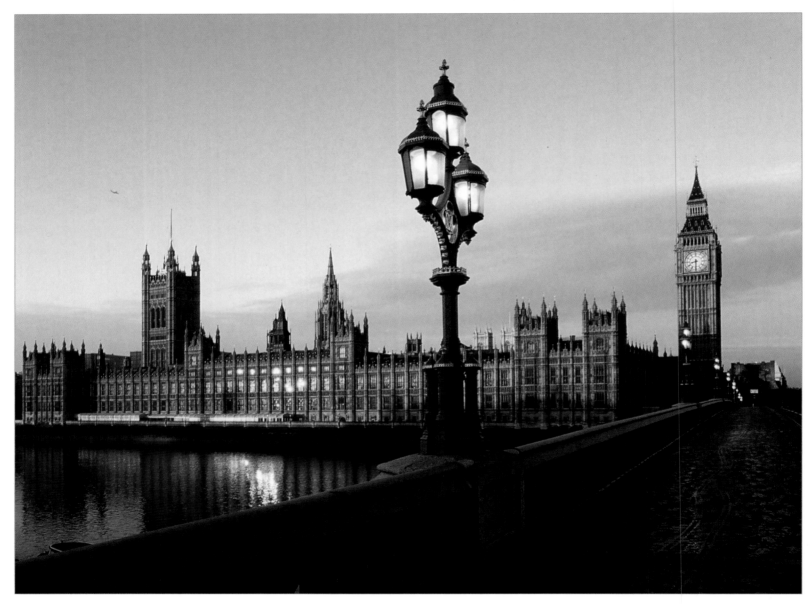

on 14 piers. Small turrets were included on the bridge as shelter for travellers, but these were soon taken over by prostitutes and murderous villains. Gas lamps were installed in 1813, and watchmen were hired to guard pedestrians. But people still did not feel safe on the bridge, which had an alarming tendency to sway, and which, despite being repaired in 1826, slowly fell apart.

In 1853 Charles Barry (the Palace of Westminster's architect) was appointed consulting architect, and Thomas Page (the architect of Chelsea Bridge) was appointed engineer for a new bridge just to the east side of the old one.

The current Westminster Bridge was opened at a quarter to four in the morning on the 24 May 1862 with a 25-gun salute. (The early opening time was chosen because it was the exact moment of Queen Victoria's birth 43 years before.) The bridge had cost £502,223 to build, including improvements to the road at either end. It was a well-constructed bridge that remained largely trouble-free for 140 years.

The bridge has seven elliptical cast-iron arches with gothic decoration, and is 827 feet long and 84 feet wide. The span of the central arch is 94 feet. It is predominantly green, the same colour as the benches in the House of Commons, which is on the same side of the Palace of Westminster as Westminster Bridge. (Lambeth Bridge is mainly painted red as it is nearer to the House of Lords.)

There is a small notice at the northeast end of the bridge listing its byelaws (1892). It is prohibited to: injure the statues, commit a nuisance, attach ropes damaging the bridge itself, disobey the weight limit and regulate traffic without the proper authority.

There are two magnificent sculptures at either end of the bridge. On the north side opposite Portcullis House there is a bronze sculpture of Queen Boadicea with her two daughters driving a chariot into battle. On the south side opposite St Thomas's Hospital is a 13-ton stone lion on a plinth. The lion was previously painted red and stood at the entrance of the old Red Lion Brewery. It was moved to its present position at the time of the Festival of Britain in 1951.

With its backdrop of Big Ben and the Houses of Parliament, Westminster Bridge is one of the most photographed and painted of all London's bridges. The annual London to Brighton veteran car rally crosses the bridge, and it was the finishing point for the first London Marathon.

In 2005 a five-year programme of repair and renovation was started. Cleaning the bridge stonework, painting the parapets and elevations, and restoring the crests, badges and historic lighting were included, as well as major structural work. When the programme is completed, the bridge will have been restored to its former majesty, truly befitting one of the great bridges of the world.

On September 3 1802, William Wordsworth wrote:

Earth has not anything to show more fair:
Dull would he be of soul who could pass by
A sight so touching in its majesty:
This City now doth, like a garment, wear
The beauty of the morning: silent, bare,
Ships, towers, domes, theatres, and temples lie
Open unto the fields, and to the sky,
All bright and glittering in the smokeless air.
Never did sun more beautifully steep
In his first splendour, valley, rock, or hill;
Ne'er saw I, never felt, a calm so deep!
The river glideth at his own sweet will:
Dear God! the very houses seem asleep;
And all that mighty heart is lying still!

Antonio Canale (Canaletto) 1697-1768

Giovanni Antonio Canale was born in Venice on 18 October 1697, and christened in the church of San Lio near the Rialto Bridge. He began his career as a pupil of Luca Carlevaris, but it was when working in the theatre in Venice – as a scene painter and designer - that the young Canaletto learnt to paint. He became known simply as Canaletto in order to distinguish himself from his father, Bernardo Canale, who was also an artist and designer. In 1720 his name was recorded for the first time in the register of the city's professional painters' guild.

Canaletto composed most of his work in Venice, including the most beautiful paintings of St Mark's Square (for travellers on the Grand Tour of Venice) as well as the canals, churches and palaces. His main patron and promoter was Joseph Smith, an Englishman living in Venice who later became the British Consul. When Smith found himself in financial difficulty, he had no choice but to sell all his Canalettos, the entire collection being bought by George III in 1762.

Canaletto himself sold many of his paintings to Englishmen; indeed he spent nine years in England between May 1746 and December 1755. His paintings of his patrons' grand houses and castles were very popular, particularly with people who had travelled through Europe on the Grand Tour. His most famous London painting is *Westminster Bridge from the North on Lord Mayor's Day 1746.* This depicts Westminster Bridge (which was still being finished) with its 15 magnificent arches in the centre, and the lord mayor's barge and other assorted river traffic in the foreground. The original painting is at the Yale Center for British Art. Canaletto also painted *London, Seen from an Arch of Westminster Bridge,* which is now in a private collection.

He returned to Venice in 1756 and was elected to the Venice Academy in 1763. He continued to live and paint in Venice right up until his death in 1768.

Canaletto's London paintings were:

London: Westminster Bridge from the North on Lord Mayor's Day	1746
London: Seen through an Arch of Westminster Bridge	1746
London: Thames and the City of London from Richmond House	1747
London: Westminster Bridge under Construction	1747

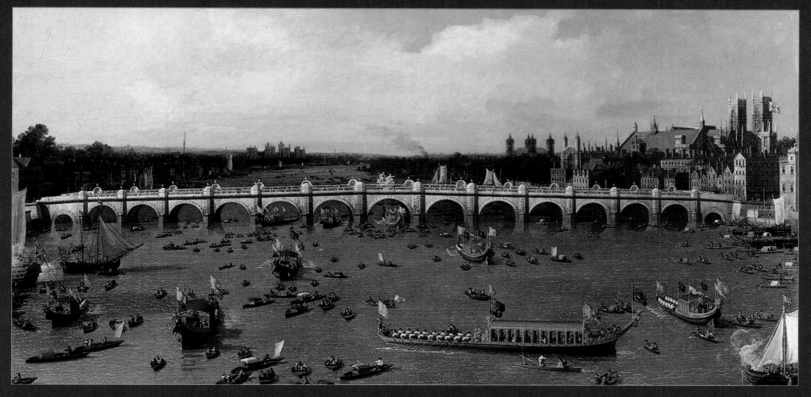

Westminster Bridge, 1746

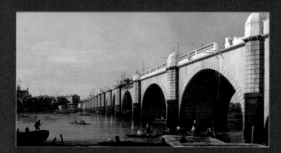

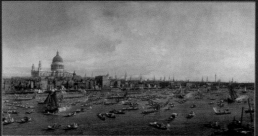

Westminster Bridge under Construction, 1747 *Thames and the City, 1747* *London Seen through an Arch of Westminster Bridge, 1746*

Lambeth Bridge

Painted red, the colour of the leather on the benches in the House of Lords.

Lambeth Bridge links Horseferry Road on the north bank of the river with Lambeth in the south and was opened by King George V and Queen Mary on 12 July 1932. It carries four lanes of road traffic and two pedestrian walkways. London County Council engineer Sir George Humphreys designed the five-span steel arch bridge with architects Sir Reginald Blomfield and Mr G Topham Forest. The bridge is 776 feet long and 60 feet wide. The central 165-foot span sits between side spans of 149 feet and 125 feet. Including the road improvements at either end, the total cost of the bridge was £936,365.

The Romans forded the Thames at the Lambeth Bridge site as early as AD48 so that Watling Street could cross the river. According to legend, this is also where the Viking King Cnut tried to order the tide to retreat. A landing stage at Lambeth is documented as the 'Great Bridge' as far back as the 14th century. This is also supposedly where Henry VIII met Cranmer, and where Elizabeth I met with Archbishop Parker.

For hundreds of years, successive Archbishops of Canterbury had owned the rights to the profitable ferry operating between Lambeth and the Palace of Westminster. Unlike most other ferries of the time, which were small boats rowed by watermen for foot passengers, the Lambeth ferry, known as the 'Horse Ferry', was much bigger. It had a flat bottom and carried horses and carriages as well as passengers. The Archbishop's ferry had a reputation for capsizing however. Over the years many passengers, including both James I and Oliver Cromwell, were lucky to escape with their lives when they were thrown into the river when the ferry keeled over.

In 1860 the Lambeth Bridge Company raised £48,924 to build an 828-foot suspension bridge with two 32-foot towers crossing the river between Market Street, Westminster, which later became Horseferry Road, and Church Street, Lambeth. The engineer was Peter William Barlow. The bridge was opened in November 1862 by a Mr Hodges, the local businessman crossing it in his new fire engine.

However, the approaches to the bridge were too steep for heavily laden horse-drawn carts, and so it was mainly used by pedestrians paying a 1d toll. Initially the bridge earned good money from these tolls, but in 1877 the Metropolitan Board of Works bought it for £35,974 and ceased charging tolls in 1879. But the bridge was unsafe and by the end of the following decade one of the piers was noticeably tilting, the iron structure was rusting and major reconstruction work was needed. In 1905 a weight restriction was brought in, and in 1911 all traffic was banned from the bridge.

In 1924 parliament agreed to fund a new bridge, with additional money to improve the approach roads. A temporary pedestrian crossing was built and demolition work on the old bridge began on 12 June 1929. The new bridge was made from steel and reinforced concrete with granite facings, and benches were positioned in the middle. Initially only the cast-iron parapets and lamp standards were decorated, but latticework pylons were added to commemorate the bridge's opening. It was once thought (apparently wrongly) that the stone pineapples on the obelisks at either end of the bridge were in memory of John Tradescant, gardener to Charles 1, and the first man to grow pineapples successfully in England.

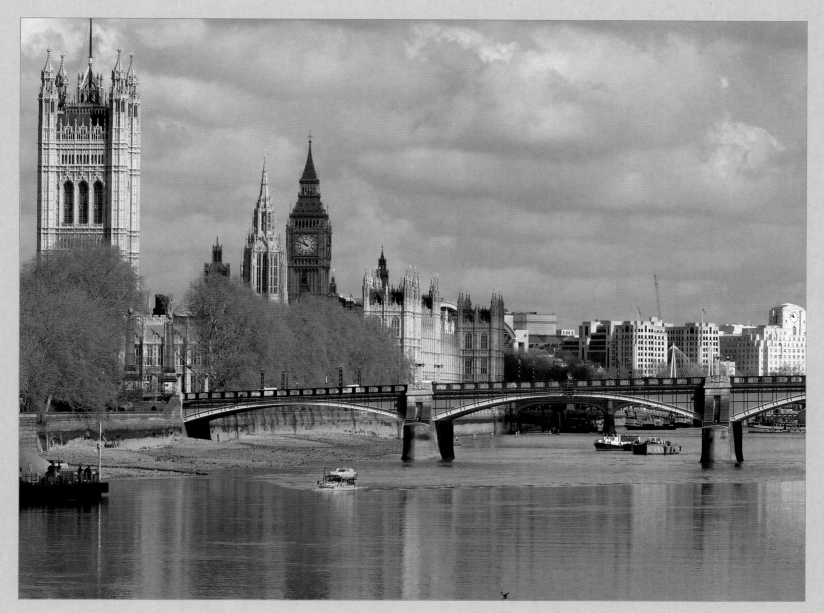

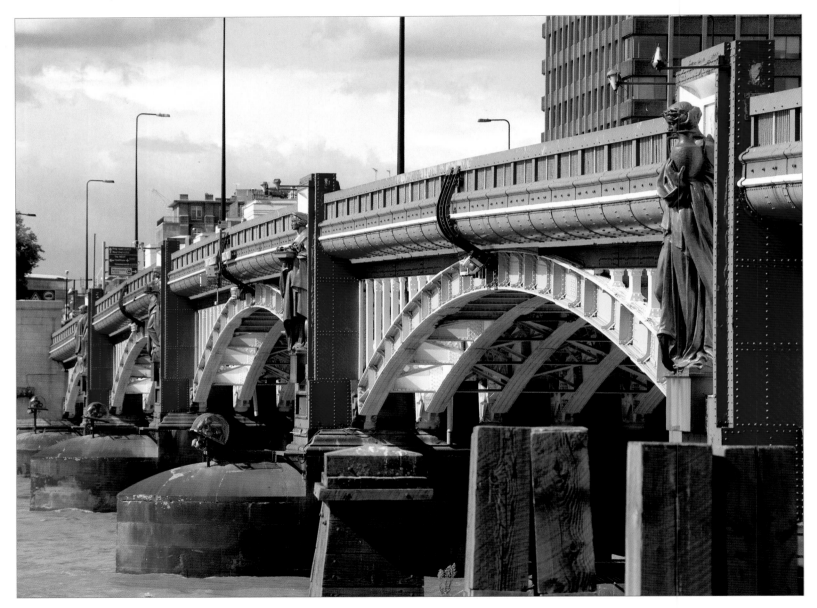

Vauxhall Bridge

Has eight huge, larger than life, bronze, female statues.

Vauxhall Bridge crosses the Thames at an acute bend in the river and links Pimlico and Westminster in the north with Vauxhall Cross, Nine Elms and Kennington in the south. Just over a hundred years old, the present bridge has five steel arches supported by granite piers and is 809 feet long and 80 feet wide. It cost £484,000 to build, which, as usual, included the cost of improving the approach roads. It was the first bridge in central London to carry trams.

The bridge is painted dark red and orange, and its most striking features are the eight huge bronze female statues standing with their backs to the bridge on the abutments. On the upstream side they represent pottery, engineering, architecture and agriculture and are the work of Frederick William Pomeroy, who also designed the Statue of Justice on top of the Old Bailey. Science, fine arts, local government and education are represented on the downstream side, and these statues are the work of Alfred Drury. The statues are illuminated at night and they are best viewed from the river rather than the bank.

In recent years two lines of oak posts dating back to around 1300BC have been discovered. This was possibly some sort of landing stage or an early bridge over the Thames, indicating that this was probably the site of an ancient settlement.

The first Vauxhall Bridge was the first iron bridge to cross the Thames in central London. It was built following an Act of Parliament in 1809 which allowed the Vauxhall Bridge Company (a consortium of local businessmen and entrepreneurs who wanted to develop the south bank of the river) to try and raise an initial sum of £200,000. John Rennie was asked to design the bridge and he outlined a blue sandstone structure with seven arches. However the design was too expensive so the company sought permission for the bridge to be made from iron instead. Rennie then designed a "light and elegant" bridge that would only cost around £100,000. But the Vauxhall Bridge Company rejected his submission and turned instead to Sir Samuel Bentham, who proposed a nine-arch iron bridge, this also being rejected, most probably because of doubts about the quality of his work. James Walker was eventually given the task of building the bridge. It was 809 feet long and 80 feet wide, with nine cast-iron 78-foot arches set on eight stone piers. It was opened on 4 June 1816 when William Williams, the company treasurer, drove across in his carriage. Tolls were 1d for pedestrians and up to 1s 6d for heavily laden wagons. The bridge had cost £175,432 to build, but there was an additional £121,556 spent on the approaches and in compensation to the ferrymen. Only £4,977 was taken in tolls in the first year and the Vauxhall Bridge Company was beset with financial difficulty. The bridge was eventually bought by the Metropolitan Board of Works for £255,000 in 1877 and freed from tolls in 1879.

In 1881 the two central piers were removed to help river traffic. They were replaced by one long arch, but because of the devastating scouring effect of the Thames, the other piers were already unstable and the bridge was in danger of collapsing. The only solution was to replace it. Work started on Sir Alexander Binnie's new bridge in July 1898 and it opened in 1906. It is now one of the busiest road traffic bridges in London carrying in excess of 50,000 vehicles a day.

Grosvenor Railway Bridge

The busiest railway bridge in London.

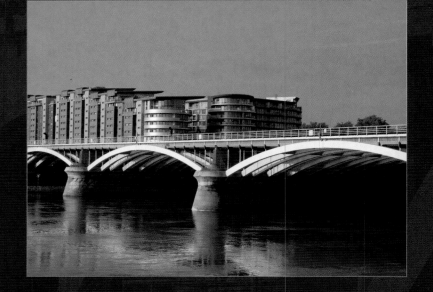

Carrying multi-track railway lines into Victoria Station, Grosvenor Railway Bridge crosses the Thames between Chelsea Bridge and Vauxhall Bridge. It was the first railway bridge to be built across the Thames in central London, and is the busiest of all the railway bridges. Although it is sometimes called the Victoria Railway Bridge, it gets its name from the Grosvenor family who once owned large parts of the Victoria area. Battersea Power Station and Battersea Park are on the south bank adjacent to the bridge, and the Royal Hospital Chelsea is on the north bank.

Grosvenor Bridge is actually three adjacent bridges carrying ten railway tracks. The first bridge was designed by Sir John Fowler for the London, Brighton & South Coast Railway. It opened in 1860 and had four wrought-iron spans; it was 700 feet long and carried four tracks over the river. Part of John Fowler's brief was to construct a bridge that was aligned with the nearby Chelsea Bridge 150 yards upstream. A second bridge, designed by Sir Charles Fox to match the first, for the London, Chatham & Dover Railway (working in conjunction with the London, Brighton & South Coast Railway), opened in 1866.

By the end of the 19th century the two bridges could not cope with increasing demand on the railways. In 1907 a third bridge was built downstream, increasing the width of the bridge to 178 feet and the number of available tracks to ten. Between 1963 and 1967 Freeman, Fox & Partners renovated and reconstructed the bridge in steel, as well as encasing the piers in concrete. This means that there are now effectively ten separate bridges each carrying one line.

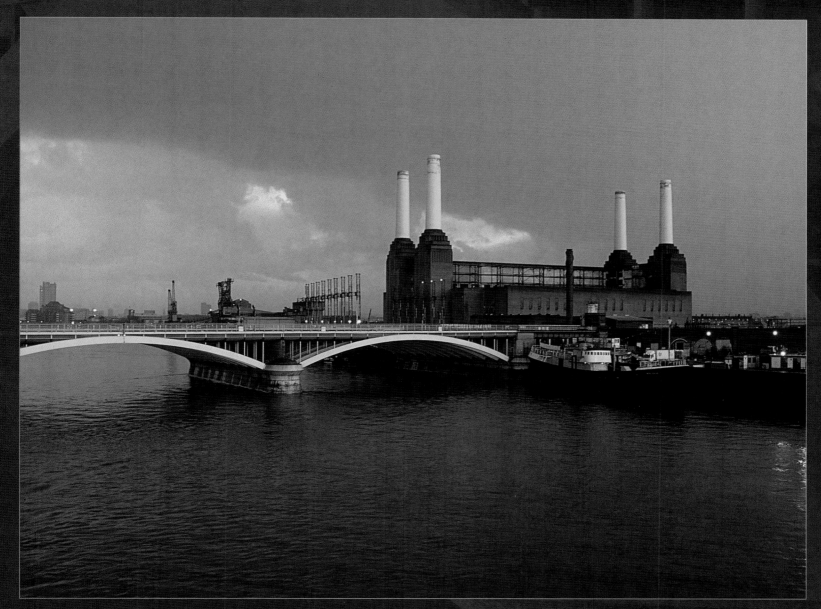

Chelsea Bridge

A unique and beautiful bridge.

Chelsea Bridge is a steel suspension bridge linking Ranelagh Gardens and the Royal Hospital in the north with Battersea Park in the south. The bridge, which was designed by Topham Forest and opened on 6 May 1937 by the Rt Hon William Lyon Mackenzie King, prime minister of Canada, has two plain towers anchoring the chains of the roadway and carries both pedestrian and road traffic. The bridge was opened five months ahead of schedule and cost £223,000, less than the original tender of £310,736 19s 2d. When illuminated at night, it is possibly the most beautiful of all the bridges.

Originally known as Victoria Bridge, the first Chelsea Bridge was designed by Thomas Page. It was an iron suspension bridge with a 333-foot middle span and two smaller 160-foot spans at either end. Tall cast-iron towers anchored the suspension chains holding the roadway. The bridge, which was one of only two that were paid for with public funds (the other being Westminster), was opened by the Prince of Wales on 28 March 1858. It had taken seven years to build at a cost of £95,000 and was a toll bridge until 1879. It was around this time that the crossing became known as Chelsea Bridge.

To begin with it was only lit on nights when Queen Victoria was in London, and as a consequence the bridge was little used. There were also initial doubts over its safety. Additional suspension chains were added in 1880 (at a cost of £11,000), but the bridge continually required strengthening work. In 1926 a royal commission recommended that a stronger and wider bridge should be built on the site, but there were still public protests when demolition work began on the original crossing in 1935.

With help from E P Wheeler, Topham Forest designed the new bridge. Rendel, Tritton & Palmer were appointed engineering consultants, while Holloway Brothers Ltd landed the building contract. The new bridge was built on foundations set inside granite and was considerably stronger than the original. The design plan required that all the materials used on the bridge must come from Great Britain and her empire, so Aberdeen and Cornish quarries were chosen for the granite, and the steel came from Scotland and Yorkshire. Asphalt was shipped across from Trinidad, while Douglas Fir wood blocks came from Canada. The bridge was built out from each bank, while the large central section was positioned on barges in the middle of the river. When the tide ebbed it simply dropped into place.

Chelsea Bridge is another of London's bridges that is decorated with heraldic work. Four tall concrete posts, two at either end of the bridge, are adorned with golden galleons and shields decorated with coats of arms. The bridge's centre section is 300 feet long and 83 feet wide. It is painted red, with blue balustrades. It carries more than 30,000 vehicles each day.

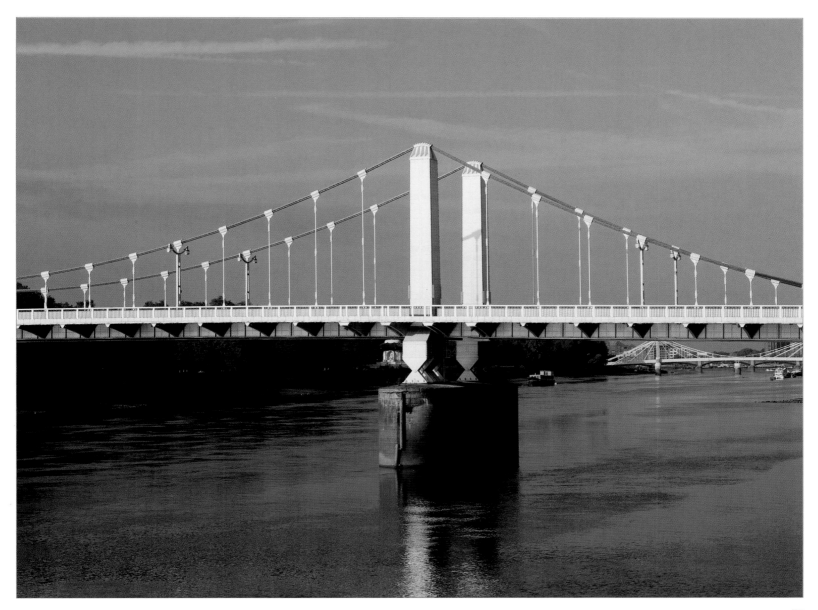

Albert Bridge

Perhaps the loveliest of all of London's bridges.

Albert Bridge, which links Chelsea on the north bank with Battersea in the south, was named in memory of Prince Albert, consort to Queen Victoria. It is a stunning bridge. Originally designed by Roland Mason Ordish as a triple-span iron suspension bridge, it is 710 feet long and 40 feet wide, with a centre span of 400 feet. It cost £90,000 and was opened in September 1873. The four original tollbooths still stand at either end of the bridge. For the benefit of soldiers stationed at the nearby barracks in Chelsea, there are notices saying 'all troops must break step when marching over this bridge'. By night 4,000 bulbs light the bridge making it one of the most spectacular sights on the river. Strangely, however, there is no statue or plaque honouring Prince Albert himself.

The Albert Bridge Company was formed on the assumption that substantial toll revenue could be made because this area of southwest London was developing rapidly. The proposed bridge faced fierce opposition from the owners of Battersea Bridge however. They eventually won an inclusion in the act of 1864, thereby forcing the Albert Bridge Company to buy the old timber Battersea Bridge when Albert Bridge opened. The company was also charged £3,000 per annum in the interim period towards the upkeep of Battersea Bridge. Despite this financial burden, the Albert Bridge Company pressed ahead, choosing Ordish to build a 'rigid' suspension bridge using his patented steel rod method instead of conventional chains. The bridge he designed had four 69-foot iron towers on cast-iron cylinders, which were filled with concrete to support the structure.

Work began in 1864 but was immediately held up while parliament debated on where the line of the Thames Embankment should be taken. The bridge was eventually opened in September 1873. By this time the company had used all of their initial £200,000 and there was still the cost of maintaining Battersea Bridge to consider. To make the matter worse, the tolls collected during the first nine months only amounted to £2,085. The Albert Bridge Company was therefore struck with a financial crisis.

Five years later, in 1878, the Metropolitan Board of Works bought both Albert Bridge and Battersea Bridge and the Prince of Wales freed the bridge from tolls on 24 May 1879. Sir Joseph Bazalgette strengthened and modernised the bridge in 1887, adding chains to give it the more usual suspension bridge appearance. The maximum weight on the bridge was limited to two tons in 1935, and the bridge was closed for repairs during the 1950s. At this time there was much talk about replacing the bridge, but the 'friends of the bridge' and a

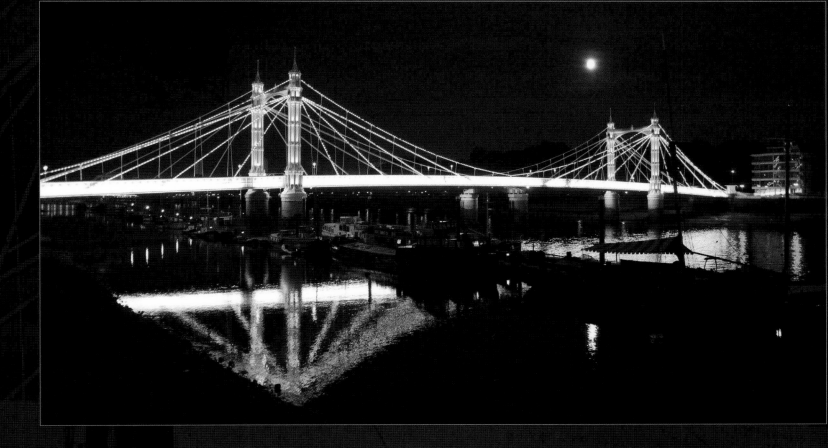

group of local residents, including Sir John Betjeman, successfully battled against this. In the early 1970s concrete piers were built on either side of the river to support the central span.

The bridge is currently painted light blue and green with small pink roses on the balustrades. The 4,000 bulbs strung along its length give it Disney-like appearance at night and an equally impressive look during daylight. There is a Derwent Wood statue of a nude female, along with the statue of a *Boy with a Dolphin* by David Wynne, on the north side. (The *Girl with a Dolphin* statue, also by David Wynne, can be found at St Katharine's Dock near Tower Bridge.)

The bridge was originally designed to carry three lanes of traffic, but this was reduced to two in 2006. Today the bridge carries fewer than 20,000 vehicles a day, the lowest number of all of London's bridges other than Southwark Bridge.

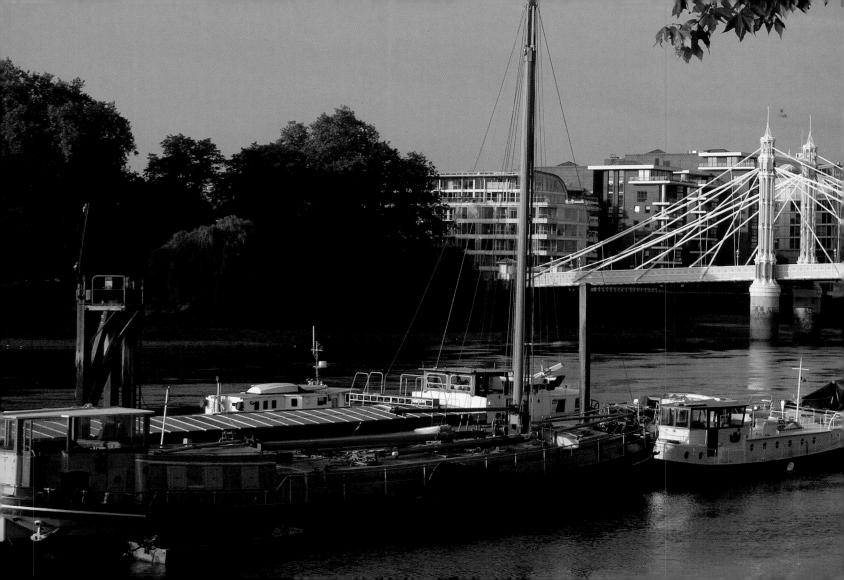

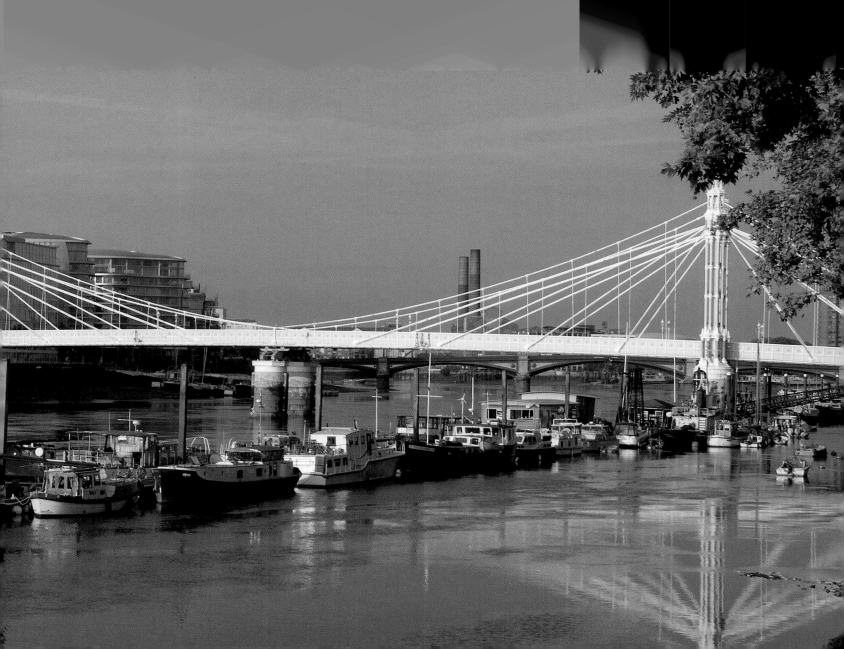

Battersea Bridge

The original bridge was much loved by artists.

The current bridge is nearly 120 years old. It links Cheyne Walk, Chelsea, in the north with Battersea in the south. It was designed by Sir Joseph Bazalgette, and built by John Mowlem & Co. The bridge was opened on 21 May 1890 by Lord Rosebery, the then Chairman of London County Council. It has five wrought-iron and steel cantilever arches mounted on four granite piers with concrete foundations. The bridge cost just £7,163, while a further £105,646 was spent on the approach roads. It is currently painted green and gold, and, with a less than 40-foot-wide roadway, it is London's narrowest road bridge. The stone bridge and its reach remains one of the most photographed and painted stretches of the Thames in London.

In 1763 John, Earl Spencer, inherited an old and somewhat dangerous ferry operating between Chelsea and Battersea. He soon decided to seek the authority to replace the ferry with 'a fine stone bridge'. Parliament agreed to his proposal and an act in 1766 gave him permission for a toll bridge. But the Earl was unable to attract either the backers or investment needed to build a stone bridge, and he soon realised that local residents were not willing to risk their own money either. Eventually a group of only 15 investors, including the Earl himself, found the £15,000 needed to finance the bridge. This was only enough for a modest timber bridge however, which was designed by Henry Holland and built by John Phillips, nephew of Thomas Phillips, who had previously built Putney Bridge.

The bridge was 28 feet wide and had 19 narrow arches, which made it very difficult for traffic to navigate the river. It opened in 1771, although carriages weren't allowed across until the following year. Tolls were ½d for pedestrians and up to 1s for a carriage drawn by four or more horses. Despite this, the first year's income was only £1,172.

Iron girders were used to strengthen the bridge in 1795, and oil lamps were added in 1799 to make the night crossing safer. Between 1821 and 1824 four-foot-high iron railings were added to replace the wooden fences.

The bridge was originally known as Chelsea Bridge but it was renamed Battersea when a new bridge was built at Chelsea. (Although Chelsea Bridge itself was originally known as Victoria Bridge.)

The contrast between light and shade on the water along Battersea Reach has made this stretch of the river popular with artists. James Whistler and J M W Turner both painted the bridge many times. Whistler's romantic *Nocturne* series of paintings were of the original Battersea Bridge and his *Nocturne: Blue and Gold – Old Battersea Bridge,* became one of his most famous paintings.

It soon became an unpopular bridge however; primarily due to the problems it caused river traffic. Boats regularly collided with its 18 wooden piers, and many boatmen drowned. It also became dangerous to cross on foot, and many a ghastly crime was committed on the bridge.

In 1864 the bridge was bought under a compulsory purchase order by the Albert Bridge Company. They then sold it to the Metropolitan Board of Works in 1879. The bridge was freed from tolls in 1880. Three years later vehicles were banned for safety reasons. In 1885 the bridge was demolished. It was the end of the last wooden bridge over the Thames in London.

Sir Joseph Bazalgette, the Metropolitan Board of Works' Chief Engineer, designed the new bridge. It was re-named Battersea Bridge and it now marks the end of one of the oldest races in Great Britain, the annual Doggett's Coat and Badge rowing race. Competitors can

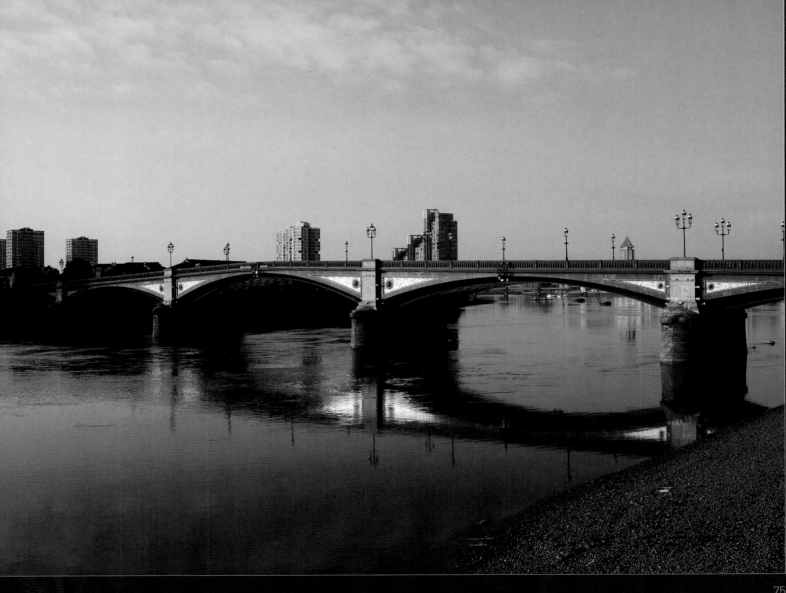

only be Thames watermen and the winner gets to keep a scarlet coat with a silver arm badge for a year. The race, which is organised by the Worshipful Company of Fishmongers, was first rowed in 1721. Thomas Doggett, an actor and theatre manager who lived in Chelsea left a large sum of money in his will to be used for an annual boat race from London Bridge to Battersea Bridge in memory of the watermen who had always rowed him safely home, sometimes in the most atrocious weather.

In more recent times, the bridge has repeatedly made the news. In 1948 a boat jammed under the bridge and her master had to be rescued from the smashed wheelhouse. A very strong wind in 1950 caused a boat carrying coal to collide with the centre pier. In September 2005 the gravel-carrying barge 'James Prior' hit the bridge. It became wedged underneath one of the arches causing considerable damage. The bridge had to be closed while the necessary repairs were made.

In January 2006 the bridge was again in the news when an 18-foot northern bottled-nosed whale swam up the Thames as far as the crossing. Sadly the whale died on a barge as it was being transported back downriver to the sea.

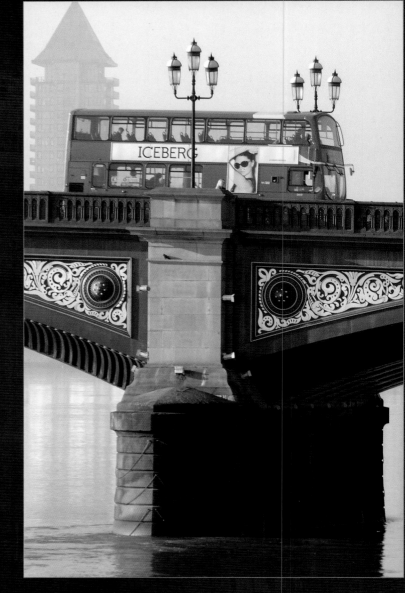

James Abbott McNeill Whistler 1834 – 1903

Whistler the American artist was captivated by Battersea Bridge and the contrast in light and shade and the effect of pollution in the air along Battersea Reach.

James Whistler was born in Lowell, Massachusetts, USA, on 14 July 1834. When he was nine his father, Major Whistler, a civil engineer hired to build the St Petersburg to Moscow railroad, moved the family to Russia. They made a brief stop in London on their way and some years later Whistler talked of his being rowed on the Thames 'by lamplight and starlight' during the visit.

While in Russia he studied at the Imperial Academy of Fine Arts in St Petersburg. After the death of his father the family returned to the United States, where, in 1851, Whistler entered the United States Military Academy at West Point. He was expelled in 1854 with a poor disciplinary record following a chemistry lesson explosion. In 1855 he travelled to Europe to study art. He remained an American citizen for the rest of his life but never returned to the USA, spending most of his time in

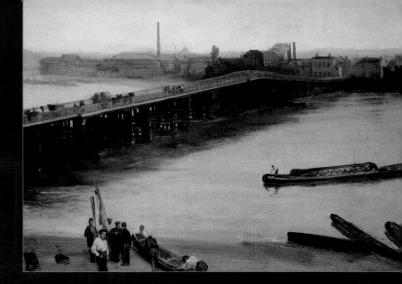

Brown and Silver: Old Battersea Bridge, 1859

France and England.

In May 1859 he moved to London, and in the spring of 1863 he moved to a house at 7, Lindsey Row (now Cheyne walk), Chelsea, very close to where Turner had lived. He hired brothers Walter and Henry Greaves to row him on the river at dawn and dusk so that he could make basic drawings helping him to memorise scenes on the river before painting them on canvas in his studio. Indeed this was how Turner had painted some 12 years earlier (with Greaves Senior, the brother's father, as his boatman).

Although Whistler saw the same reach from his windows

that Turner had so enjoyed, by now the vista had changed dramatically. The Battersea riverside had become very industrial, with a continuous row of factories, wharves, warehouses and mills belching large clouds of steam and coal smoke. Whistler's famous paintings of the old Battersea Bridge do not show the crowded riverside however, but they concentrate instead on the atmospheric effect on the water, particularly in the evening. He described this everyday scene thus: 'when the evening mist clothes the riverside with poetry, tall chimneys become campanili (church bell towers) and the warehouses are palaces in the night and the whole city hangs in the heavens and fairy land is before us'.

He used the term *Nocturnes* in place of *moonlight* as titles for his works. His *Nocturne in Blue and Gold: Old Battersea Bridge,* along with *Nocturne in Grey and Gold, Westminster Bridge,* are examples of this. This *Nocturne* series of paintings were to have an immense influence on modern painting.

Whistler believed that art was about 'the beautiful arrangements of colours in harmony' and not necessarily about the actual representation of the facts. This drew him into a heated and ongoing argument with the critic John Ruskin. In 1878 Whistler sued Ruskin for libel after he had condemned one of his paintings. Whistler won the case but was awarded only a farthing in damages. The cost of the case left him with serious financial difficulties.

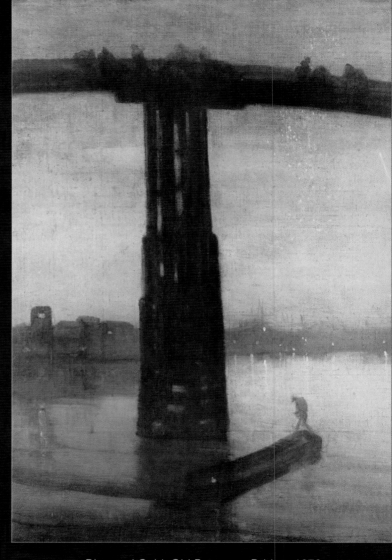

Blue and Gold: Old Battersea Bridge, 1872

He was a friend of Oscar Wilde and a great wit himself. When he read of his own death in an obituary in a newspaper, he wrote to the paper saying that reading about his death had 'induced a tender glow of health'.

In 1896 he stayed in rooms on the sixth floor of the Savoy Hotel. From his suite he could see the Houses of Parliament, Westminster Bridge and Charing Cross Bridge (Hungerford Bridge) to his right, and Waterloo Bridge to his left. While he was at the Savoy he created a wonderful series of lithographs of Waterloo Bridge. His wife died soon after he had produced these prints and he never painted or drew the Thames again. He died on 17 July 1903 and was buried at St Nicholas's Church in Chiswick.

Whistler painted Battersea and Westminster bridges many times. His most famous paintings of the bridges are:

Brown and Silver: Old Battersea Bridge	1859
Old Westminster Bridge	1859
Westminster Bridge in progress	1861
The Last of Old Westminster (bridge)	1862
Grey and Silver: Old Battersea Reach	1863
Symphony in Grey: Early Morning Thames (Battersea Reach)	1871
Nocturne in Blue and Green (Battersea Reach)	1871
Nocturne: Grey and Gold - Westminster Bridge	1871
Nocturne: Blue and Silver - Cremorne Lights	1872
Nocturne: Blue and Gold - Old Battersea Bridge	1872

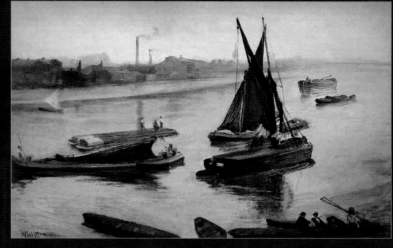

Grey and Silver: Battersea Beach, 1863

Nocturne: Grey and Gold - Westminster Bridge, 1871

Battersea Railway Bridge

Carries the only north – south railway link through London.

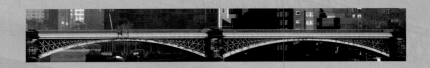

Battersea Railway Bridge was originally called the Cremorne Bridge, and it's still sometimes referred to as Battersea New Bridge. It crosses the Thames between Battersea and Chelsea, and is between Wandsworth Bridge upstream and Battersea Bridge downstream.

The bridge consists of two sets of railway lines and is 670 feet long. It has five lattice girder arches supported by four brick river piers and is clad with Brambly Fall Stone set onto concrete foundations. It is part of the West London line linking Clapham Junction to Willesden Junction, though today it is mainly used by freight trains. The bridge was designed by William Baker, chief engineer of the London and North Western Railway, and opened in March 1863 at a cost of £87,000. It has been strengthened twice, in 1969 and 1992. Trains using the bridge have to observe the 15-mile-per-hour speed limit.

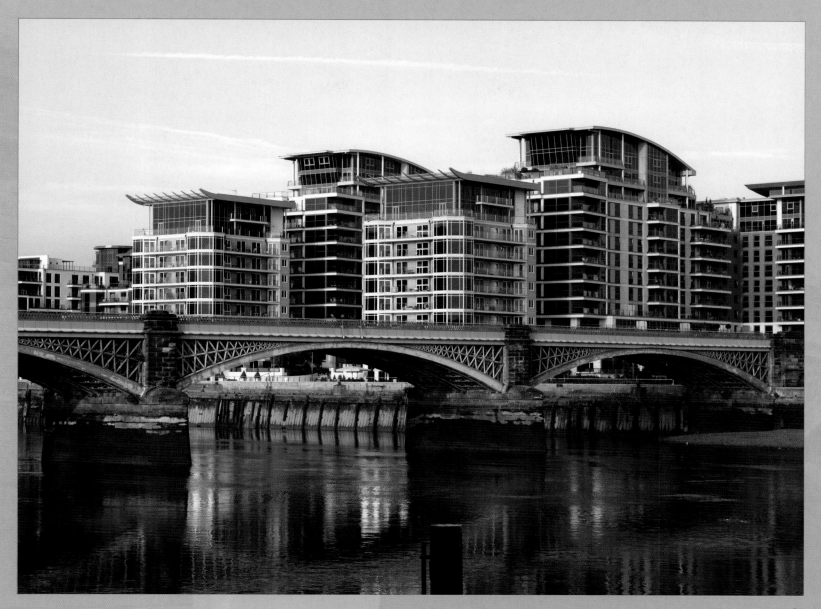

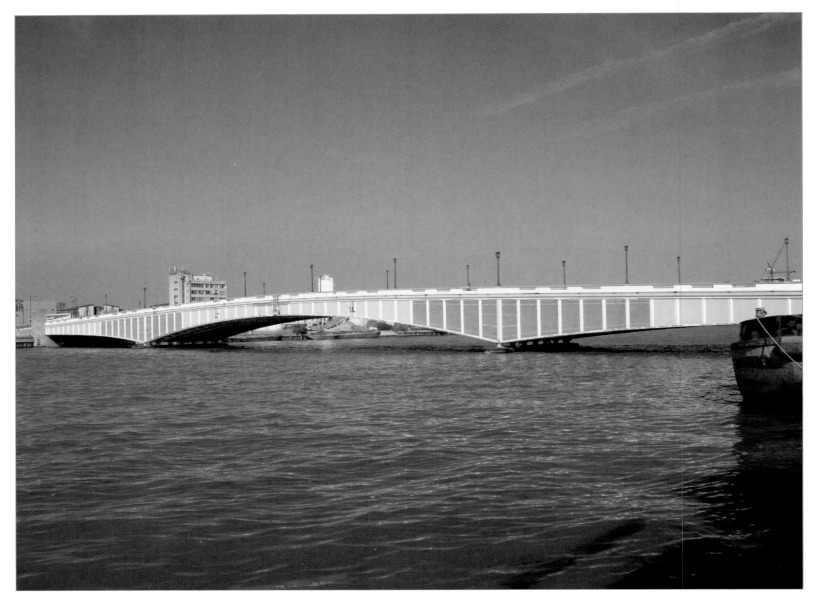

Wandsworth Bridge

London's busiest road traffic bridge.

Wandsworth Bridge links Fulham and Parsons Green on the north bank with Battersea and Wandsworth in the south. The current triple-span steel and cantilevered bridge was built on two piers. It was designed by Sir Peirson Frank and opened on 20 September 1940 at a cost of £262,000, of which £215,000 was for the bridge itself. It is the busiest of all London's bridges with nearly 60,000 cars crossing the bridge daily. It is also one of the most unattractive. Only the cladding of the piers and the granite pylons in each corner lighten what is a drab utilitarian construction. This image is not helped by its blue steel coloured panels.

The parliamentary acts giving permission to build both Wandsworth Bridge and Albert Bridge were given royal assent on the same day, 25 June 1864. The original plan was for both bridges to be designed by Rowland M Ordish, and then built at the same time. Construction was delayed however because of parliament's indecision on the build-line of the Thames Embankment. The original plan was therefore abandoned and Wandsworth Bridge became a wrought-iron five-span bridge with a wooden roadway and iron lattice girders designed by Julian Tolme.

The bridge eventually opened in 1873. A Colonel Hogg performed the opening ceremony, which was followed by a celebration buffet arranged by Mrs Hammond from The Spread Eagle pub. The bridge was not pretty. Non-matching materials had been used and it was an ugly shape.

Toll charges were ½d for pedestrians and 6d for carts, but the crossing was not busy initially. This was probably because drainage problems on the roads on the north side made it difficult to get to the bridge. As was usually the case, investors in Wandsworth Bridge lost money, and it was eventually bought by the Metropolitan Board of Works for £52,000 in 1878. It was freed from toll in June 1880.

Like many of London's bridges it was unable to cope with an increase in traffic and London County Council commissioned a new bridge in 1935. A temporary bridge, which had previously been used during the widening of Chelsea Bridge, was reconstructed alongside the old one while the first Wandsworth Bridge was dismantled.

Sir Peirson Frank's new bridge was finally opened in 1940 but the Wandsworth residents were to be disappointed again. Instead of an attractive new bridge, they ended up with a boring girder design with three steel spans that is unlike any other London bridge. Having been widened in 1970, the bridge is now 664 feet long and 60 feet wide. Its centre span is 200 feet.

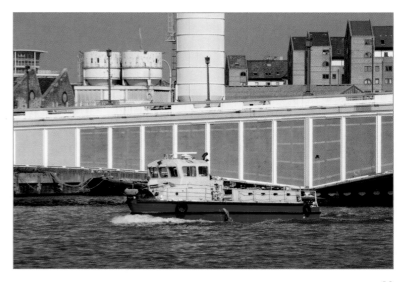

Putney Railway Bridge

Carries two railway tracks for the
London Underground's District Line.

Putney Railway Bridge, which is sometimes referred to as Fulham Railway Bridge, is adjacent to the Putney road bridge. Today it is used by the London underground to carry the District Line over the Thames. It links East Putney station on the south side of the river with Putney Bridge Station in the north.

The bridge is 750 feet long and has five wrought-iron lattice girders (with another three over land, two on the south side and one on the north) positioned on four pairs of cast-iron cylinders. W H Thomas and railway engineer William Jacomb designed the bridge, and it was built by contractors Head, Wrightson & Co for the London and South West Railway. It opened in 1889 but was never given a name. It quickly became known as the 'Iron Bridge' by the locals however. It is a robust, functional bridge, which is currently painted a turquoise-green colour. A pedestrian walkway runs along one side.

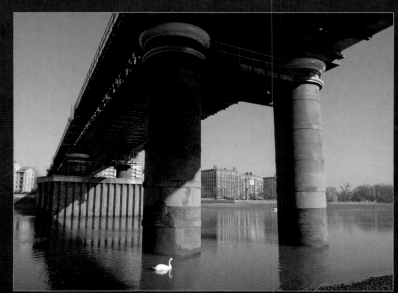

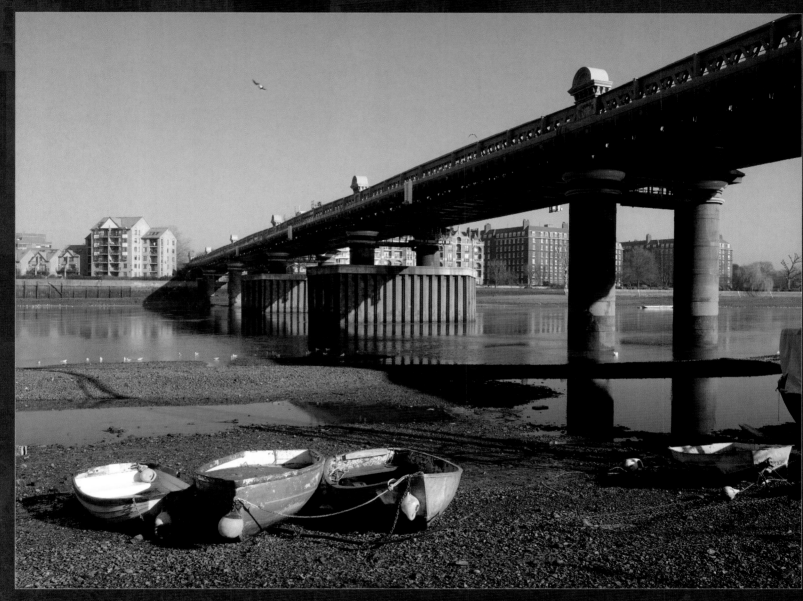

Putney Bridge

The start of the Oxford – Cambridge Boat Race course.

This is a road and pedestrian bridge linking Putney in the north and Fulham in the south. It is also the starting point of the annual Boat Race, which has been rowed the 4 miles and 374 yards upstream from Putney to Mortlake since 1845.

Prime Minister Sir Robert Walpole exerted enough pressure on parliament for them to act, in 1726, to allow the first bridge. A second act a year later meant that the company of proprietors of Fulham Bridge had to raise £30,000 in £1,000 shares, but first they had to buy out the ferry, which was jointly owned by the estates of Fulham and Wimbledon, and licensed to the Bishop of London and the Duchess of Marlborough. The Bishop received £23, the Duchess £364 10s and David Pettiward and William Skelton £7,999 19s 11d between them. This was approximately twenty times the ferry's annual income. A further £62 per annum was to be paid to the churchwardens of Fulham and Putney so that they might distribute it among the widows and children of the watermen.

Designed by Sir Jacob Ackworth and built by Thomas Philips, and originally known as Fulham Bridge, the crossing did not run straight across the river but ended up a strangely curved wooden construction instead. It had 26 arches, with openings varying from 14 to 32 feet wide, and cost £9,455 to build. The Prince of Wales opened the bridge on 14 November 1729 and shared out £5 among the workmen. It was the first bridge to be built over the Thames since London Bridge and Kingston Bridge were built in the 13th century.

Four toll collectors were employed for the booths at either end of the bridge. People seemed reluctant to pay the tolls at first and the collectors were given staves to help persuade them. In 1730 bells were fitted to the booths so that the collectors could ring for assistance if they felt threatened.

Apparently so many people crossed the bridge on 25 May 1767 to see George III review his troops on Wimbledon Common that more than £63 was collected in tolls.

In October 1795 it was recorded that Mary Wollstonecraft planned to commit suicide by hurling herself from the bridge after returning from Sweden and finding her lover Gilbert Imlay to be intimately involved with a London actress.

In 1870 the bridge was badly damaged when a river barge collided with it. A 70-foot iron girder was used to strengthen the crossing but it became clear that the entire structure would have to be replaced.

The bridge was bought by the Metropolitan Board of Works in 1879 and freed from toll in 1880 and shortly thereafter a replacement bridge was designed by Sir Joseph Bazalgette (the first of his four London crossings) and was built by John Waddell & Sons. It took four years to build and was opened on 29 May 1886 by the Prince of Wales, later King Edward VII. It was called Putney Bridge and was widened in 1933.

The bridge now carries four lanes of traffic and has wide pedestrian pavements on either side. It is built from Cornish granite and concrete, and has five river arches and four concrete piers. The bridge is 700 feet long – with a centre arch of 140 feet – and 74 feet wide; it cost £240,433 to build. It is an impressive, solid and elegant looking bridge, which is used by some 60,000 vehicles a day. There is little decorative design on the bridge, the main features of which are eight sets of trident lights with heraldic designs at the base.

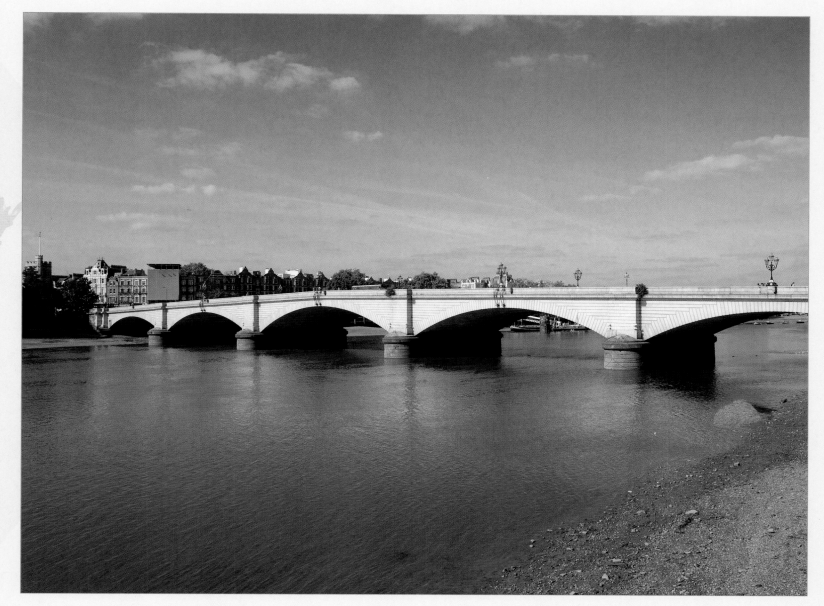

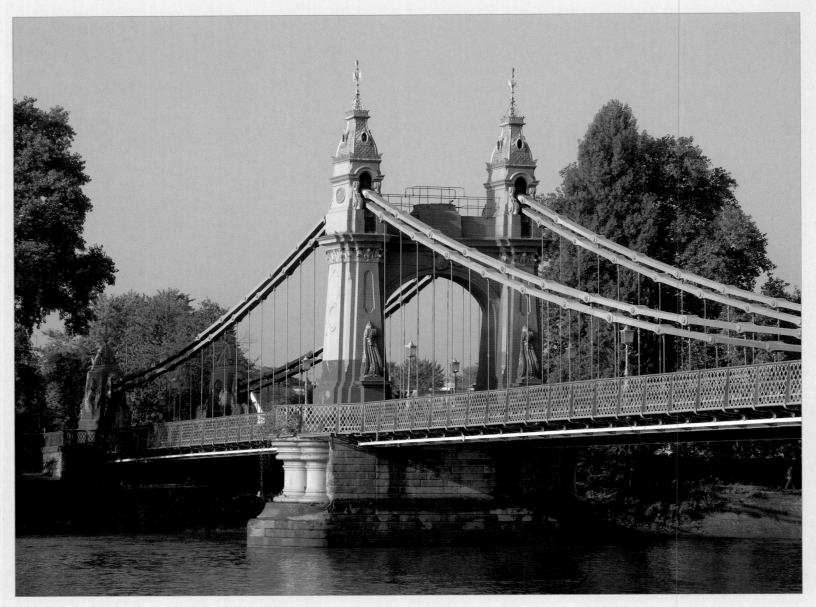

Hammersmith Bridge

The lowest bridge over the Thames in London.

Hammersmith Bridge links Hammersmith in the north with Barnes in the south: it opened on 11 June 1887. It was designed by Sir Joseph Bazalgette, cost £82,117 and rests on the same foundations as an earlier bridge. It gives the impression of immense power and is certainly one of the most attractive bridges across the Thames, especially when lit up at night.

Today the bridge is too narrow to cope with the volume of traffic so it uses a priority system for buses and a maximum weight limit of 7½ tons. It has the lowest clearance of all the bridges and passengers on the pleasure boats need to keep their heads down if their boat passes beneath it at high tide. An Act of Parliament in 1824 sanctioned the building of the first suspension bridge across the Thames, and William Tierney Clark, who lived in Hammersmith, designed it. The foundation stone was laid by HRH the Duke of Sussex on 7 May 1825. He was heard to incant the following while pouring corn over a brass plate fixed onto one of the cofferdams, into which had been placed gold coins and a silver Masonic trowel:

I have poured the corn, the oil and the wine, emblems of wealth, plenty and comfort, so may the bridge tend to communicate prosperity and wealth.

On the evening of 8 October, with bands, fireworks, the firing of cannon, and with the bridge decorated with flags and bunting, Lord Ellenborough rode across at 10.00pm to declare the bridge open. It had cost £43,341 10s 9d to build, including the octagonal tollbooths at each end. Tolls were set at ½d for pedestrians and up to 6d for a horse-drawn carriage.

The bridge had two brick piers on each bank, on top of which stood a pair of masonry towers with arched entrances. Chains, initially anchored to both banks, were then anchored again on the towers to hold the 400-foot timber deck in place. It was a good-looking bridge that became popular with river traffic because there was easy access between the two piers instead of the usual multiple arches. By 1870 however there were already fears over the bridge's safety. At the University Boat Race between 11,000 and 12,000 people crowded onto it to watch. As spectators ran from one side to the other to watch the crews pass beneath, the bridge swayed alarmingly. There were also fears that the deck was not strong enough to carry the increasing volume of traffic. In 1880 the Metropolitan Board of Works bought the bridge for £112,000, and on 26 June the Prince of Wales declared the bridge toll free. In 1884 a temporary structure was built while work started on a new bridge.

The Bazalgette-designed bridge still stands today. It has two heavy ornamental cast-iron towers at each end supporting steel suspension chains, is 700 feet long and 43 feet wide, with 400 feet between the uprights. It is painted green and gold, and has heraldic crests on the four towers representing the UK, London & Westminster, Guildford and Colchester & Kent. There are seats in the middle of the bridge for those who want to stop and enjoy the view.

Unfortunately this bridge has been plagued with problems. The decking was replaced in the 1970s, with the cables being replaced the following decade. The IRA tried to blow it up three times (1939, 1996 and 2000), and it was closed to all traffic for strengthening for most of the 1990s. It was suggested then that the bridge might not open to road traffic again, but thankfully it was.

Barnes Railway Bridge

Three spans of wrought-iron bowstring girders.

The first bridge, which opened on 22 August 1849, was designed by Joseph Locke and built by Thomas Brassey. It had three 120-foot spans supported by narrow masonry piers and was built for the London & South Western Railway to carry the loop line from Barnes to Hounslow via Chiswick. By the early 1890s, however, the bridge was unable to accommodate the increasing number of trains using the line.

A new 360-foot bridge boasting three wrought-iron bowstring girder spans and built by contractors Head, Wrightson & Co was opened in 1895. Incidentally, Joseph Locke's original bridge still stands next to the new bridge, though it is not used. On 2 December 1955 thirteen people were killed on the bridge when a passenger train ran into a goods train travelling in the opposite direction.

Barnes Railway Bridge is well known to followers of the Boat Race as it offers wonderful grandstand views of the last bend. In fact the crew that leads at the bridge usually goes on to win the race.

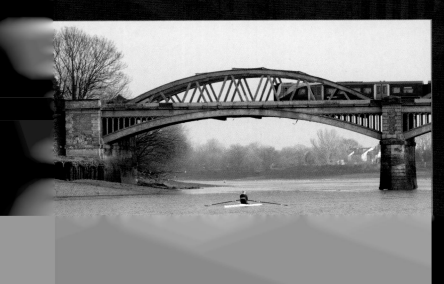

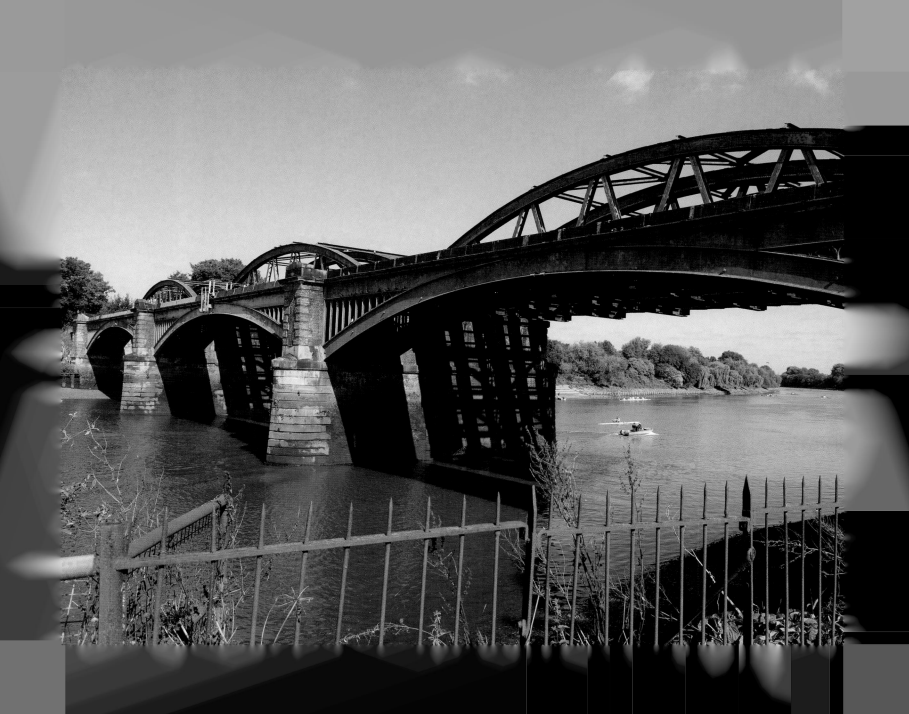

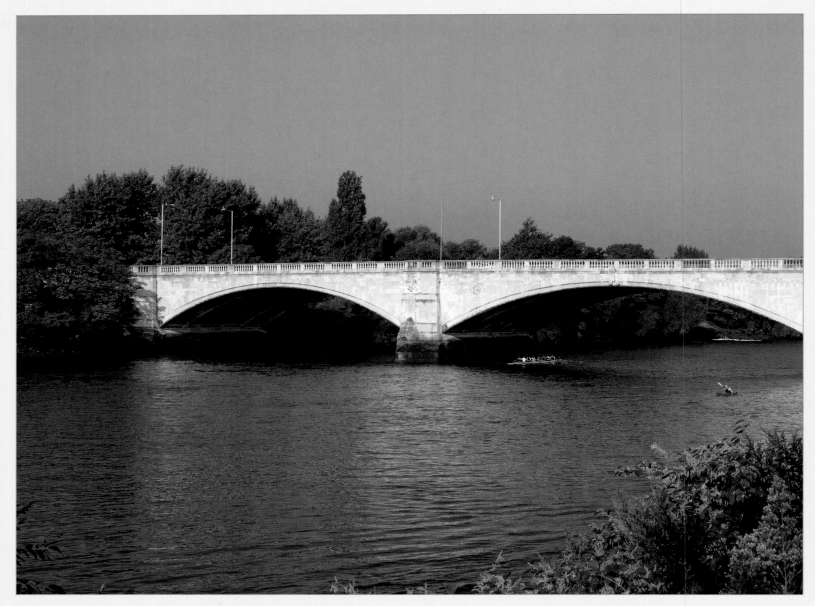

Chiswick Bridge

The end of the Boat Race course.

This elegant triple-span bridge is one of the newer bridges over the Thames and is probably most famous for being close to the Boat Race finish line. In fact the crews tend to slow down under it immediately after finishing the race. The bridge links Mortlake and Barnes in the south with Dukes Meadows and Chiswick in the north. It was built as a link on a busy commuter route (the A316) in southwest London, and was part of the Road Improvement Programme, which became known as the Great Chertsey Road scheme.

The same parliamentary act gave Middlesex and Surrey County Councils permission to begin work on both Chiswick and Twickenham bridges. The former was designed by Sir Herbert Baker, had the aptly named Alfred Dryland appointed engineer, and was built by the Cleveland Bridge & Engineering Company of Darlington for £208,284. The Ministry of Transport bore 75% of the cost and the two county councils paid the balance.

The Prince of Wales, later Edward VIII, opened the bridge on 3 July 1933, the first of three bridges he opened that day. It is a strong, functional and elegant bridge, similar in design to Twickenham Bridge. It has three flat ferro-concrete arches faced in 3,400 tons of Portland Stone, and is 607 feet long and 70 feet wide between the parapets. The centre arch spans 150 feet, which, at the time it was built, was the longest concrete span over the Thames.

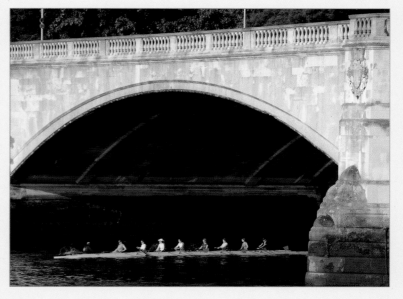

Kew Railway Bridge

Adjacent to the Strand-on-the-Green.

Kew Railway Bridge crosses the Thames at the delightful Strand-on-the-Green slightly downstream from Kew Bridge. Permission for the bridge was granted in 1864 as part of the link to Richmond. This iron lattice girder bridge, designed by William Robert Galbraith and built by Brassey & Ogilvie for the London & South Western Railway, opened in June 1869. The bridge, which is painted light green, is 575 feet long and has five wrought-iron spans supported by cast-iron columns with ornate tops. It carries two railway lines across the river.

The bridge, which is sometimes known as the Strand Bridge, is now owned by Network Rail and is used by both mainline trains and the London Underground's District Line. It crosses the river between the famous pubs The City Barge and The Bull's Head on a charming section of riverbank.

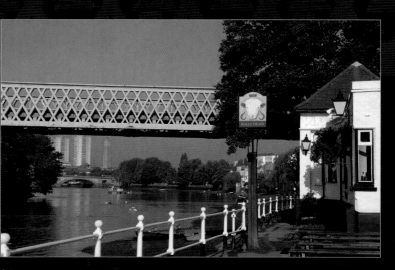

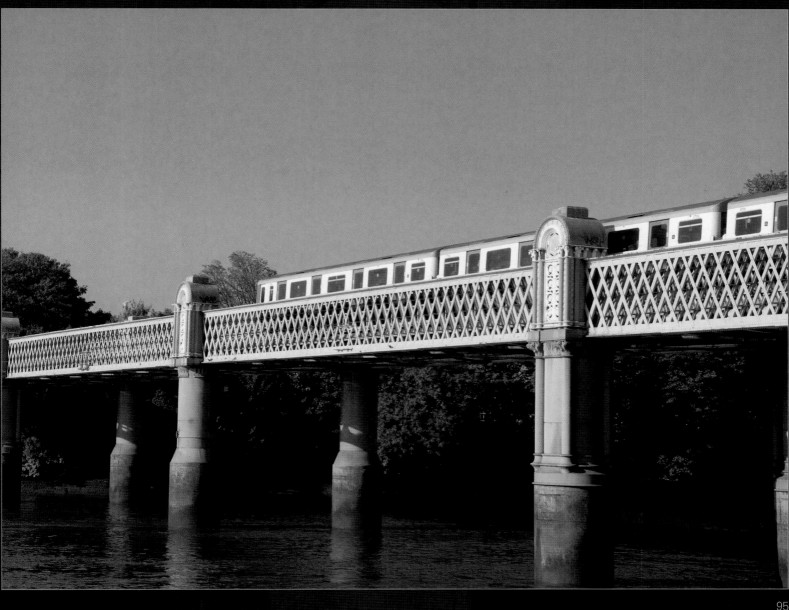

Kew Bridge

Originally named King Edward VII Bridge.

Three bridges have spanned the Thames at Kew since 1759, linking Brentford and Strand-on-the-Green on the Middlesex bank with Kew on the Surrey bank. The present bridge, which cost local taxpayers £250,000, was originally named King Edward VII Bridge, in honour of the then monarch, but for some reason the name was not popular and after only a few years it became known as Kew Bridge again.

A ferry had been operating at the bend in the river for hundreds of years before there was any thought for a bridge at Kew. The Tunstall family had owned and run the ferry since 1659 and it was Robert Tunstall who, in 1757, finally received permission to build a bridge. Some of the local barge masters objected to the proposal however. They claimed that it would be very difficult to navigate a bridge on the bend, so the initial permission was withdrawn, authority being given soon thereafter for a bridge about a hundred yards downstream.

Kew Bridge was the fourth to cross the tidal Thames. Work began on John Barnard's wooden design in early 1758 (Barnard was also the master carpenter for Westminster Bridge) and the bridge opened to the public on 4 June 1759. More than 3,000 people paid to cross on the first day. Tolls were 1d for pedestrians and up to 1s 6d for a coach and six horses. On 1 June, however, just before the bridge

was finished, it was specially opened at the request of the Dowager Princess of Wales and her son, the future King George III, so that they might use it instead of the ferry. For granting her this favour Mr Tunstall personally received £200, and was asked to share 40 guineas among his workmen, yet the wooden bridge would only last thirty years before a stone bridge was built to replace it.

Authority to build the second bridge was given to Tunstall's son in 1782. James Paine, who had earlier worked on Richmond Bridge, designed a new bridge just to the east, which was built from Portland and Purbeck stone. It cost £16,500, which was funded by a tontine, a sum of money raised by the sale of shares. An annual dividend was paid on these shares, but when each shareholder died their shares were then divided up between the others until one shareholder received 100% of the dividend. The first time a tontine was used to raise money for a London bridge was for the first Richmond Bridge in 1774. In 1819 the Tunstall family sold the bridge to a Mr Robinson for £23,000. He quickly became aware of the popularity of Kew Gardens, and was given permission in 1848 to build a large landing stage by the bridge for steamboat passengers to embark. On 8 May 1873 the bridge was freed from toll having been bought by the Metropolitan Board of Works for £57,300. By the 1890s it was clear that the bridge was too narrow and could not cope with the increasing volume of traffic and in 1898 consent was given for a new bridge. Sir John Wolfe Barry and Cuthbert Brereton designed the current bridge, and built it between 1899 and 1903. Edward VII laid the last coping stone with a silver trowel, and the ceremony was followed by a lavish celebration at Kew Gardens and a huge a tea party for a thousand children in a marquee on Kew Green.

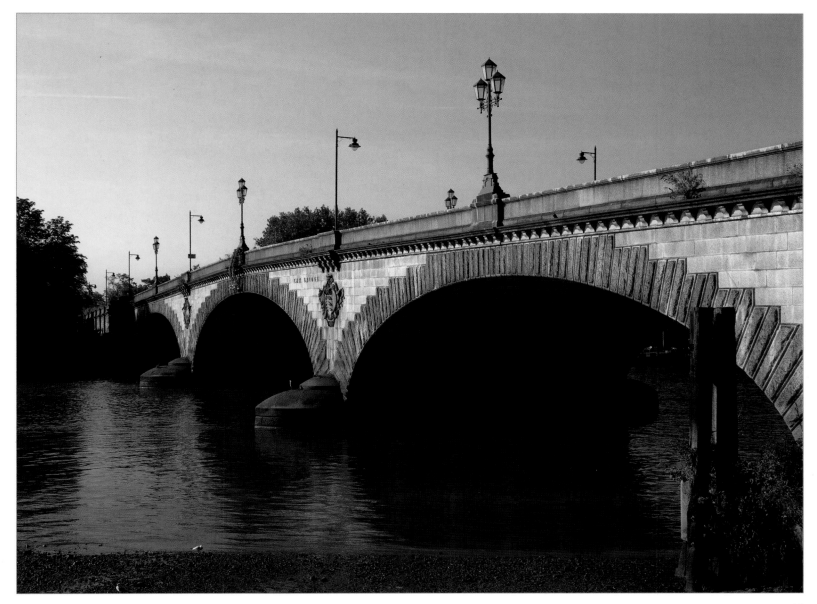

Richmond Lock and Footbridge

The last crossing to abolish tolls.

An Act of Parliament in 1890 granted authorisation to build a half-lock and weir downstream from Richmond Bridge. Ransomes & Rapier began building this complex structure in July 1892 under the supervision of Thames Conservancy engineers James More and F G M Stoney.

The Duke and Duchess of York (later King George V and Queen Mary) opened Richmond Lock and Footbridge on 19 May 1894. The footbridge, which is painted pale green, is 300 feet long and 28 feet wide and crosses the half-tide and barrage lock, which is the furthest downstream of all of the locks on the river. The lock can accommodate six river barges at one time and is owned and operated by the Port of London Authority.

The sluice gates which make up the barrier are raised for about two hours either side of high tide. They were originally hand-cranked but are now raised and lowered electrically.

This was the last bridge over the tidal Thames to collect tolls. The pedestrian toll was 1d when it was introduced in 1894, but this was dropped during the Second World War and never reinstated.

A £4,000,000 refurbishment of the lock and weir was undertaken in the 1990s. HRH Prince Andrew, Duke of York, was the guest of honour at the centenary celebrations in 1994.

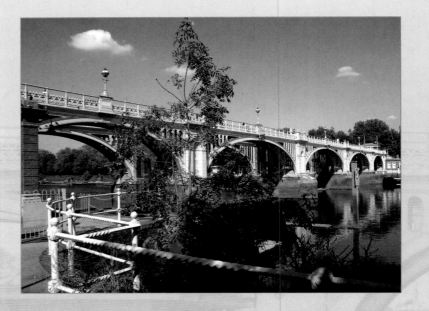

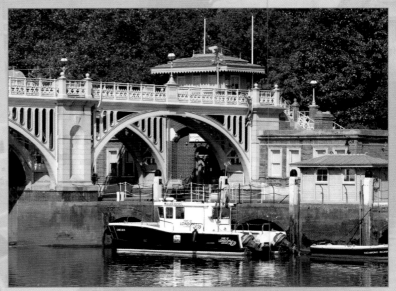

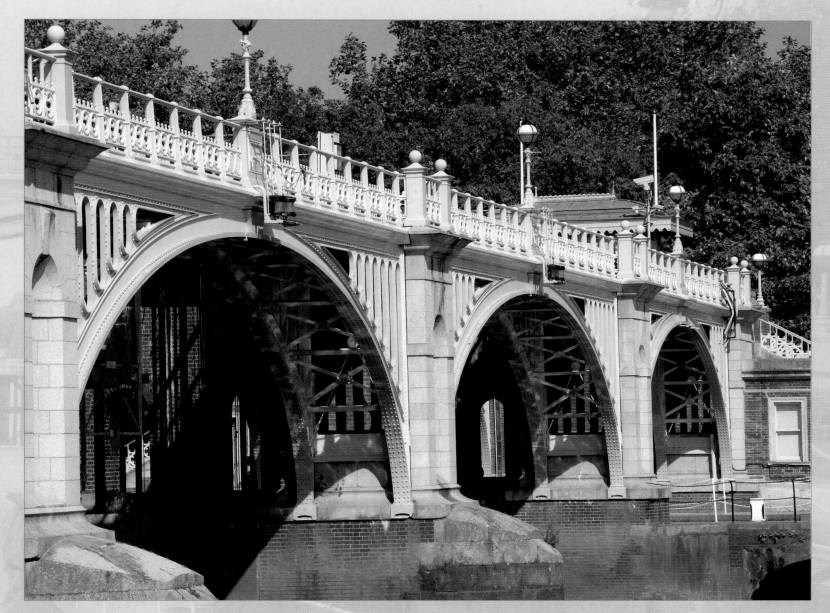

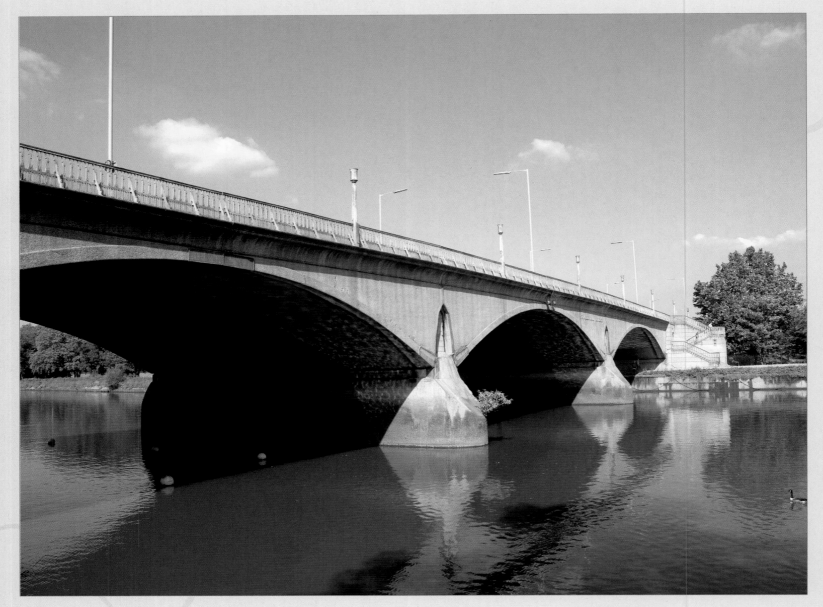

Twickenham Bridge

The first bridge in Britain to be designed with hinges allowing for movement due to temperature changes.

Twickenham Bridge was the second of three new bridges opened by the Prince of Wales on 3 July 1933. Designed by Maxwell Ayrton, it is a busy modern road bridge carrying 46,000 vehicles on the A316 to and from London every day.

The bridge has three reinforced concrete river arches with bronze balustrades and lamps. The unique feature of the bridge is its permanent hinges, which allow for adjustment according to the temperature. The bridge links St Margaret's on the Middlesex side with the Old Deer Park on the Surrey bank. It is 280 feet long and 70 feet wide and was built to relieve pressure on the busy southwest road routes around London.

A bridge over this point in the river just downstream from Richmond was first put forward in 1909 in a proposal to the Board of Trade. But World War I, then the Depression, followed by a shortage of money and materials, halted any plans for a new bridge. Twenty-two years later Twickenham Bridge became part of the 'Great Chertsey Road Improvement Scheme' that was approved by parliament in 1928. The other bridges involved in the plan were Hampton Court Bridge and Chiswick Bridge. At that time there was a degree of local objection to the bridge because one of the approaches cut through the famous Old Deer Park. And for a short time it became known as 'the bridge that nobody wants'.

Aubrey Watson Ltd won the £191,200 contract to build the bridge on 1 June 1931. Architect Maxwell Ayrton and engineer Alfred Dryland worked together with consulting engineers Considere Construction Ltd. At first sight the triple-arched ferro-concrete structure looks like a stone bridge, but it is in fact made from stone-clad concrete. In all 45,000 tons of concrete, 7,000 tons of Portland cement and 800 tons of steel were used in construction. The piers are set on a footing of compressed cork.

Richmond Railway Bridge

The first railway bridge over the Thames in London.

Richmond Railway Bridge crosses the Thames between Twickenham Bridge downstream and Richmond Bridge upstream. The bridge takes the South West Trains line from London Waterloo to Reading and links Richmond and St Margaret's stations. It was part of a new six-mile line connecting Waterloo and Richmond via Clapham Junction.

Built between 1846 and August 1848 the first railway bridge at Richmond was a cast-iron beam structure. Designed by Joseph Locke, it was built for the Richmond Company by Thomas Brassey. It was originally called the Richmond, Windsor and Staines Bridge and was the first railway bridge over the Thames in London.

In 1908 the Horseley Bridge Company built a 300-foot bridge designed by engineer J W Jacomb-Hood using the original piers and abutments, in effect making two separate bridges. This was strengthened again in 1984 and is currently painted green and yellow.

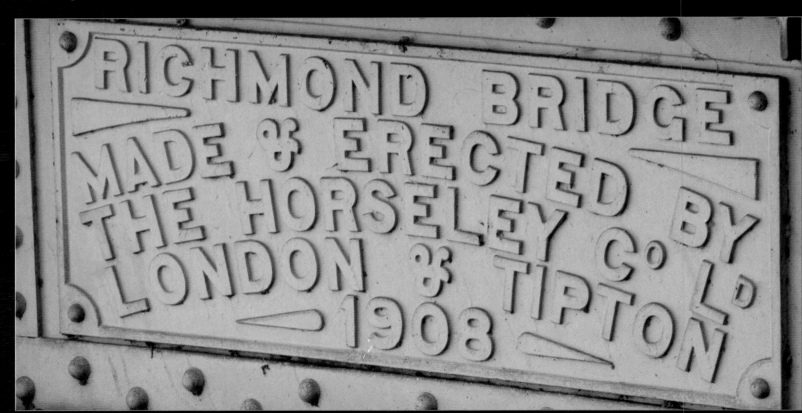

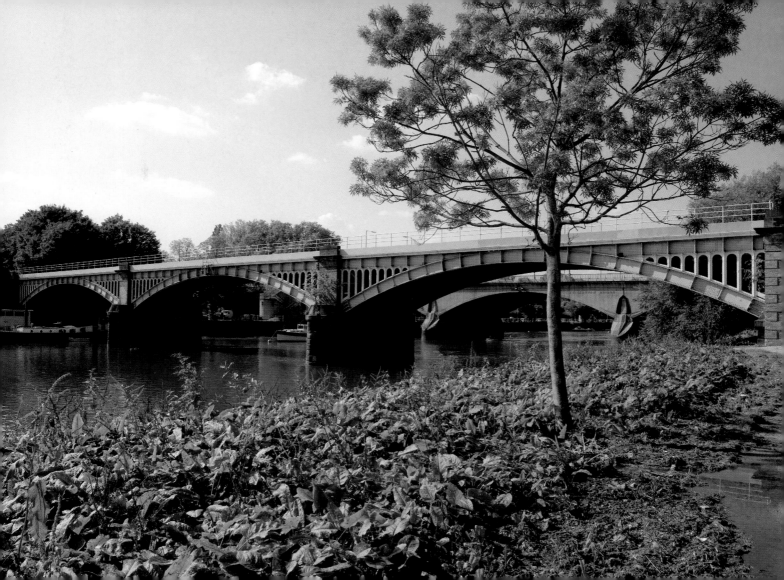

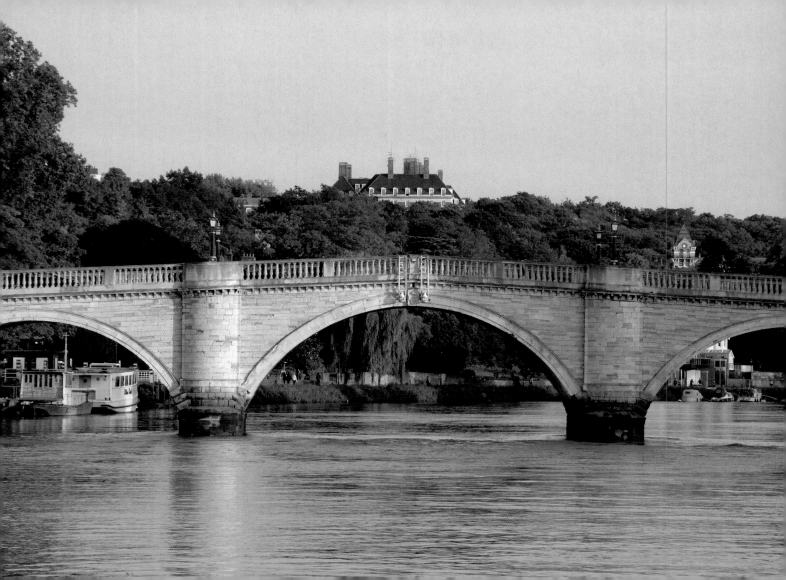

Richmond Bridge

The oldest bridge still in use over the 'Royal River'.

Richmond Bridge is the oldest surviving bridge over the tidal Thames. The original Portland Stone bridge designed by James Paine and Kenton Couse was opened in 1777. The total cost for the bridge and its approaches was £12,783. Cleveland Bridge & Engineering Company widened the bridge from 24 feet to 36 feet in 1937 and with its five river arches it is 300 feet long. It links the centre of Richmond on the Surrey side with St Margaret's on the north bank.

Henry VIII's household accounts show payments to the ferry-keeper at Richmond. In those days the ferry was two different boats, one for passengers and the other for horses, small carts and general goods. Larger carriages and heavy goods had to go further upstream and cross the river at Kingston Bridge. In 1760 records show that the ferry was leased to William Windham. He applied to the treasury for permission to build a bridge but it took until July 1773 before an Act of Parliament finally gave the necessary authority for the bridge. The Hon. Henry Hobart laid the foundation stone on 23 August 1774 and the bridge was opened to pedestrians at the end of September 1776. It opened to other traffic on 12 January 1777 although the bridge had still not been finished.

The magnificent new bridge had 13 arches, five semicircular river arches and a causeway of five brick arches on the Middlesex side and three on the Surrey side. The bridge was built by Thomas Kerr and cost £10,900. GR III is carved into the stone above the central arch. Funding came from tontines of £20,000 and £5,000 (in £100 shares) with the extra money being used to pay compensation to local landowners. There were two tollbooths and tolls were set at the same price as the ferry, ½d for pedestrians and up to 2s 6d for a six-horse coach.

The new bridge quickly became popular and was described at the time as 'a simple, yet elegant structure, and, from its happy situation is one of the beautiful ornaments on the river'. Both J M W Turner and John Constable painted the bridge, as did numerous artists throughout the 18th and 19th centuries.

The bridge was freed from toll on 25 March 1859, following the death of the first tontine's last living shareholder. The tollhouses were removed and replaced with iron seats in 1868. These are still in use today on the Richmond end of the bridge. There were a number of proposals to widen the bridge during the early years of the 20th century. In 1927 the bridge was transferred to Middlesex and Surrey County Councils, but it wasn't until 1933 that they agreed to widen it. The Cleveland Bridge & Engineering Company started work in 1937 removing and numbering each stone on the upstream side before replacing them after the piers and cutwaters had been extended. It was difficult and painstaking work, which took two years and cost £73,000. It was ultimately successful though and the work left the bridge looking as if it had just been built in the late 18th century style. If you look under the bridge arches today you can still see where it was extended.

J M W Turner 1775-1851

Turner was another artist who was fascinated by the river and by London's Bridges. Joseph Mallord William Turner was born to working class parents in Covent Garden, London, on 23 April 1775. Turner was always going to be a painter and from his early childhood his drawings were proudly displayed by his father in the window of his hairdressing shop in Maiden Lane.

When he was ten he was sent to live with an uncle in Brentford, a small town on the banks of the Thames to the west of London. It was here that he first really became interested in painting. He was then sent to school in Margate close to the Thames estuary. Turner was a prolific talent. His first exhibit at the Royal Academy was a watercolour in 1790 when he was only 15. He was one of the founders of English watercolour landscape painting and was known as 'the painter of light'. In a career that lasted for more than half a century he produced a vast range of work – mainly landscapes – in watercolours, oils and paints.

Turner was among the huge crowds that lined the Thames on the evening of 16 October 1834 as a ferocious fire burnt down most of the Palace of Westminster. As he moved from one vantage point to another on the riverbank he quickly sketched a number of watercolours. From these he produced the fiery and dramatic composition *The Burning of the House of Lords and Commons* the following year. It is in oil on canvas and also shows the damaged Westminster Bridge engulfed in a ball of fire on the right. The original is now hanging in the Philadelphia Museum of Art. He composed two similar paintings but they were both from distance, one of which hangs in the Tate Britain. Also to be found in the Tate Britain is Turner's *The Thames above Waterloo Bridge,* painted between 1830 and 1835.

In 1846, at the age of 70, he moved into a house in Chelsea (6, Davis Place, Cremorne New Road, which is now Cheyne Walk), where he lived incognito as Admiral Booth. From this house he could see two of the Thames's finest reaches. He watched the river and sky by day and night, either from his balcony or from a rowing boat on the water.

He watched the Industrial Revolution unfold first hand, noticed the increasing smog and pollution over the river, and knew it had a terrible impact on the environment. London was then the largest industrial city in the world and this dense fog became an unpleasant and serious problem. The pollution produced some magical effects,

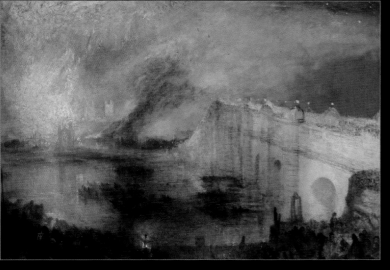

The Burning of the Houses of Lords and Commons, 1834

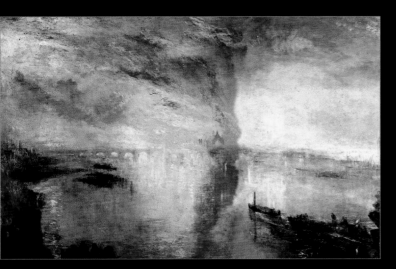

The Burning of the Houses of Parliament, 1834

glorious vistas and spectacular sunsets, which Turner adored however.

He died on 19 December 1851 in his house in Cheyne Walk, Chelsea, aged 76. He had collapsed on the bedroom floor while trying to get to the window to look at the river. His doctor told of how 'just before 9.00am the sun broke through the cloudy curtain, which so long had obscured its splendour, and filled the chamber of death with a glory of light'.

John Ruskin said in 1843 that 'Turner was the greatest artist that ever lived.' Certainly at the time of his death he was accepted as the greatest landscape painter of the 'English School'. Turner was buried in St Paul's Cathedral next to the other famous painters.

In 2005, Turner's fantastic *The Fighting Temeraire* painting was voted Britain's greatest painting in a BBC poll. It hangs in the National Gallery.

Turner's paintings of London's Bridges	
Moonlight, A Study at Millbank	1797
Watercolour of Richmond Bridge	1805
The Thames near Walton Bridge	1807
The Burning of the Houses of Parliament	1834
The Burning of the Houses of Lords and Commons, October 16th	1834
The Thames above Waterloo Bridge	1835

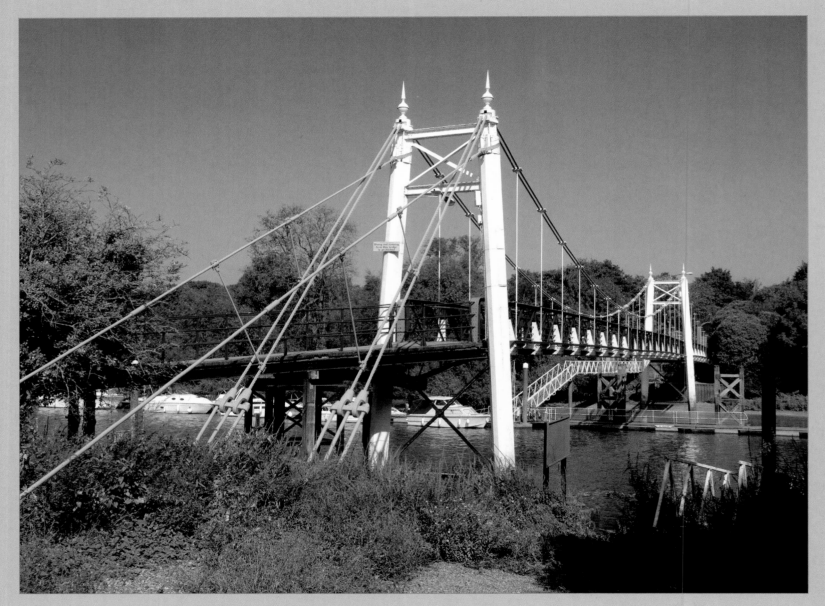

Teddington Lock Cut Footbridge

*Two footbridges of very different design
meet on the island at Teddington.*

Before Teddington Lock was built in 1889, the Thames was a tidal river as far as Kingston. Work on a footbridge to replace the ferry at Teddington started in 1887 and was finished in 1889. It was designed by G Pooley as two different bridges, which then met on the island at Teddington. The bridge from the Middlesex bank is a suspension bridge, while the one from the island to the Surrey bank, the shorter distance, is an iron girder design and is painted blue. The suspension bridge is the more picturesque of the two bridges. The bridges were funded by donations from local residents and businesses.

Teddington Lock marks the Thames's furthest upstream point still controlled by the Port of London Authority. The lock is owned and managed by the Environment Agency, which is responsible for the river further upstream. The lock and surrounding area have been recently renovated as part of the Thames Landscape Strategy initiative.

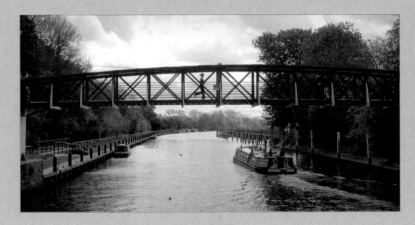

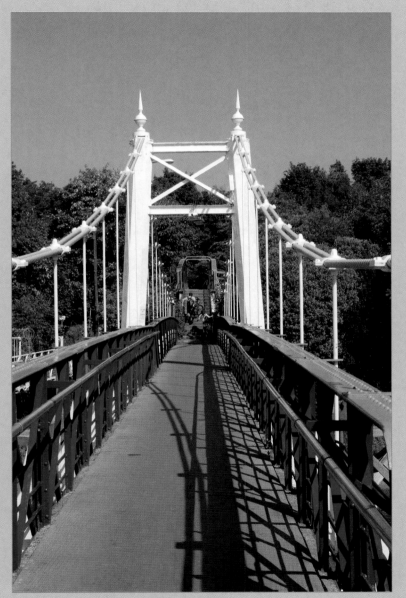

Kingston Railway Bridge

Carries South West Trains to Richmond.

Kingston Railway Bridge crosses the Thames just to the north of the Kingston road-bridge. It carries South West Trains on the London-Waterloo to Shepperton line linking Kingston and Hampton Wick stations. Permission for the bridge, which was originally built for the London & South Western Railway, was given in the Kingston Railway Extension Act of 1860. The bridge was designed and started by J E Errington just before he died. William Robert Galbraith, with Thomas Brassey as the main contractor, finished the bridge in 1863. Its five 75-foot spans are built from cast-iron arched ribs and supported on masonry piers.

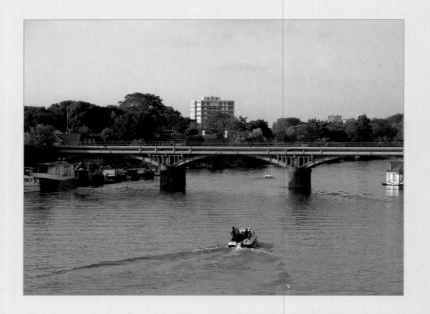

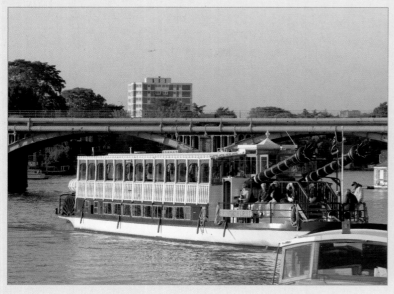

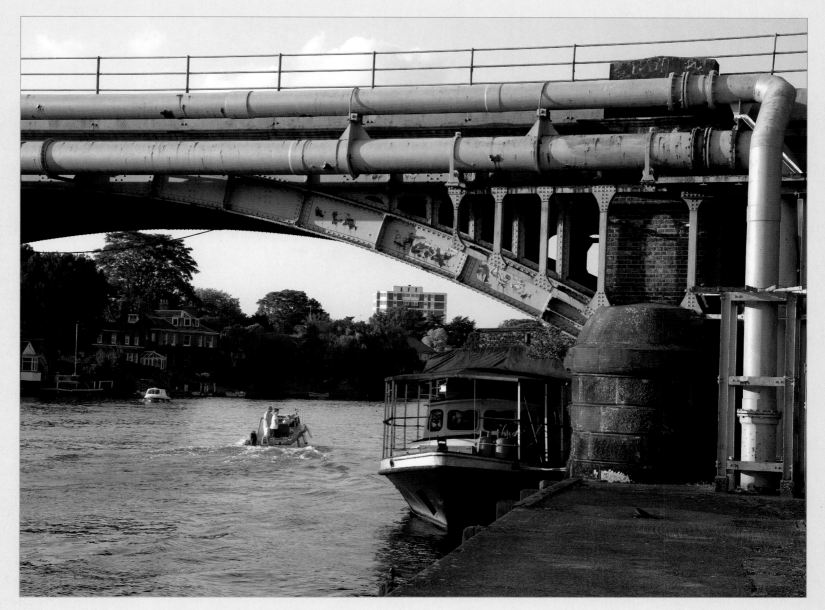

Kingston Bridge

There has been a bridge here since the 1200s.

Kingston Bridge today stands where a bridge of some description has crossed the Thames since the early 13th century, and there was probably a crossing here as far back as Saxon and even Roman times. The current bridge, which is built from Portland Stone with five elliptical arches and two small floodwater arches, was designed by Edward Lapidge and opened by the Duchess of Clarence on the 12 July 1828.

The approaches to the bridge were widened in 1906, and between 1911 and 1914 its width was doubled on the downstream side. The bridge was widened again in 2000-01 and now boasts four traffic lanes, two cycle lanes, a bus lane and wider pavements. It still retains its original Edward Lapidge design though. The Duke of Kent unveiled a tablet at the centre of the bridge on 29 June 2001 commemorating its completion.

Kingston Bridge links Kingston-upon-Thames town centre with the grounds of Hampton Court Palace, Bushy Park and Hampton Wick. It carries an average of 50,000 vehicles a day, with up to 2,000 vehicles an hour crossing during peak times. The town of Kingston is referred to in Jerome K Jerome's novel 'Three Men in a Boat'.

Kingston-upon-Thames was the first crossing point over the river upstream from London Bridge for over five hundred years (until Putney Bridge was built in 1729). How long a bridge has been here is uncertain, but in Roman times the Thames was tidal as far as Kingston and the town could be reached by sea-going ships. It remained tidal until the mid-19th century, when locks were built at Teddington and Richmond. Kingston was therefore an important trading centre for many centuries.

An old plaque on the current bridge reads as follows: 'An ancient wooden bridge existed about 50 yards downstream from here. It was under the charge of a 'Master and Brethren' endowment with a small estate, a Bridgehouse and Chapel'. We know that in 1209 King John gave the town's merchants permission to build a bridge over the river in return for a payment of £100. William de Coventry was appointed as the first Bridge Master of Kingston in 1219, an office that would remain for another 600 years.

In 1223 the bridge was reported to be 'in a decayed and poor state', and Henry III ordered that Matthew FitzGeoffrey and Henri de St Albans should be given the materials to repair it. The rickety wooden bridge would require continuous repair throughout history in fact. In 1318 the Freemen of Kingston declared the bridge to be in a 'dangerous condition', and Edward II gave them a six-year grant. In 1368 John Lovekyn, who was Lord Mayor of London four times, left £10 in his will, which was to be spent on repairing the abutments. In 1375 the bridge was again reported to be in 'a ruinous state and going to decay'. To make matters worse, there was only £53 10s of bridge monies left. So the Freemen of Kingston sent a Humble Petition to Edward III. In a letter dated 30 April 1377 the king gave permission to charge vessels passing under the bridge a levy (as well as carts over it) for the next 51 years. Henry VI renewed this 51-year-decree on 2 February 1428. During the Civil War some of the arches were demolished so that a drawbridge could be built. Unfortunately this only weakened the bridge further.

Parish records show that a new ducking stool was added in 1572. 'A woman who slandered, or a wife who nagged' would be tied to the stool and ducked in the water as punishment. At Kingston this was accomplished using a beam, which was slung out from the centre

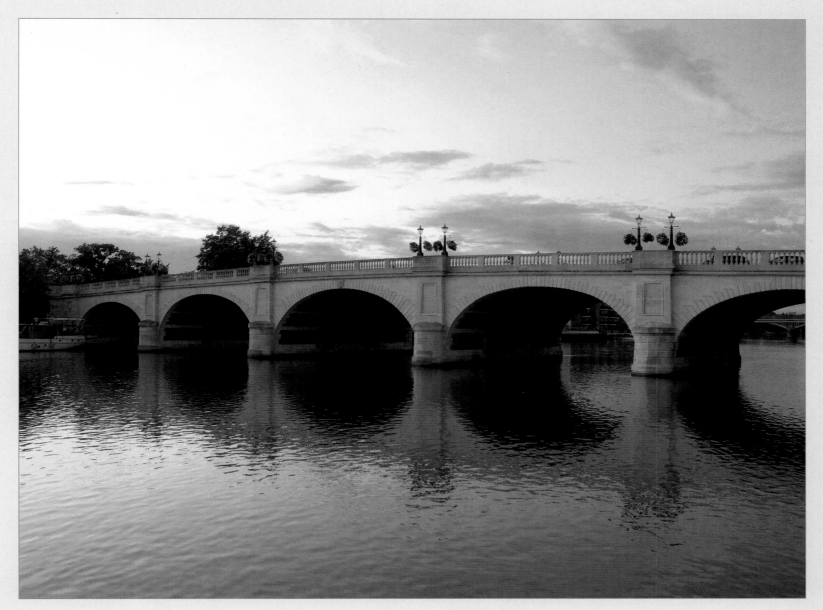

arch of the bridge. The new stool was first used on Tuesday 19 August when Mrs Downing, the grave digger's wife, was ducked three times. The stool was still in use in 1745 when the Evening Post reported that a crowd of two to three thousand watched as 'the woman that keeps The King's Head was ducked for scolding'.

By 1791, the bridge was again in a state of disrepair. Some minor improvements were made and the Middlesex end was widened. The bridge was now profitable; with tolls contributing up to £130 a year, but it became the cause of many disputes. There were fights between carters over who had the right of way over the narrow bridge, while barge masters continually complained about the narrow arches. Many barges were damaged trying to navigate the bridge and an 1802 report proposed a much larger centre arch to accommodate the increasing number of boats on the river. With no money available, however, nothing happened.

Following a severe frost in January 1814 a large section of the bridge collapsed and, although it was repaired, it was obvious that a new bridge was needed. (Stonework from the old bridge is displayed in the under-croft of the John Lewis store, and some cobbled remains of its approach roads can still be seen on the river walk.)

An Act of Parliament dated 10 June 1825 described Kingston Bridge as the 'Great Bridge over the Thames being in a decayed and dangerous state'. In it, the Kingston Corporation was authorised to borrow up to £40,000 to build a new bridge within two hundred feet of the original crossing. The loan was to be repaid and the bridge was to be maintained using toll money, and then it would be handed over to the counties of Middlesex and Surrey.

Edward Lapidge, the Surrey county surveyor, was chosen to design the bridge. The Earl of Liverpool, High Steward of Kingston, laid the first stone on 7 November 1825. William Herbert of Berkeley Square

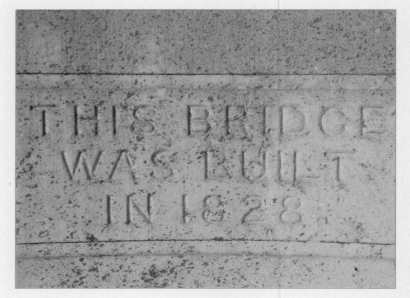

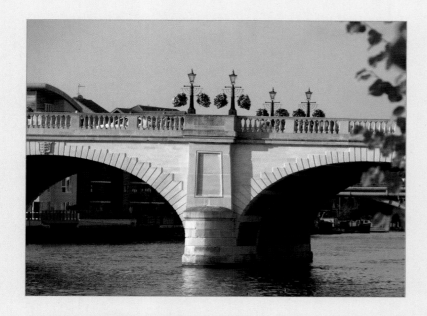

then built the new 382-foot by 25-foot bridge from Portland Stone. It had five elliptical arches with classical Greek balustrades, and two small floodwater arches at each side. The bridge was opened on 12 July 1828 by the future Queen Adelaide, Consort to William IV and the then Duchess of Clarence (after whom the new approach was named Clarence Street).

Lapidge estimated the cost of the bridge, the two circular tollhouses and the new approach on the town side at £26,800. Pedestrians were charged ½d to cross, or 1d if they were wheeling a barrow. Animals cost 1½d, or 3d if they were pulling a cart. Tolls collected in the first year amounted to almost £2,000. The bridge was finally freed from tolls – after 650 years – on Saturday, 12 March 1870. Riding on a white horse, Alderman Gould watched the removal of the tollgates, handed the gate key to the lord mayor, stood up in his stirrups and shouted, 'The bridge is free!' A 21-gun-salute followed and every church bell in the vicinity rang out in joyful celebration. These celebrations, which went on for three days, included a firework display by Mr C T Brock of Crystal Palace and finished with the tollgates being burnt on Hampton Green.

By 1906 increased traffic meant that the bridge and the approaches had to be widened. In 1911 engineers Mott & Hay (now Mott, Hay & Anderson) were commissioned by Surrey and Middlesex representatives to double the width of the roadway by extending the bridge on the Richmond (downstream) side. The contract specified that the bridge must keep its original appearance, however. The work cost £66,000 and the bridge was re-opened in October 1914. Other than the two toll houses, which were no longer there, the bridge looked almost identical to Edward Lapidge's original 1828 bridge. The upstream side was widened and strengthened again in 2000-01, but still retains its original look. It is 313ft long and 79ft wide.

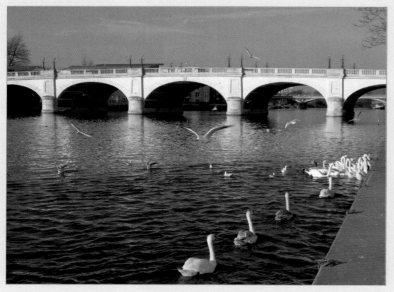

Hampton Court Bridge

Designed to blend in with Hampton Court Palace.

Hampton Court Bridge links Hampton Court Palace on the north side of the river with Hampton Court Station in the south. The current bridge, opened in 1933, is the fourth to cross the Thames here. There had been a hamlet at Hampton for centuries (it is listed in the Domesday Book as Hammstone) but there was no regular ferry here until 1536, 22 years after Cardinal Wolsey had bought the nearby manor house and 11 years after he was forced to 'give' his unfinished palace to a jealous Henry VIII as a 'present'. The population of Hampton grew rapidly around the time of the 1665 plague as wealthy Londoners fled the city but it wasn't until the mid-1700s that a bridge over the river became a possibility. In 1750 James Clarke III, the ferry owner and Lord of The Manor of East Molesey obtained the right to build a bridge and to charge tolls for 25 years. The foundation stone was laid on 9 October 1752 and the bridge opened in December 1753, an exotic seven-arched wooden structure with a definite Chinese look about it. Although it was a wide bridge the arches were very narrow causing river traffic problems and it had a large hump in the middle making it difficult for carts and carriages to cross. It soon became clear that the bridge had been poorly built and was unstable.

A second and much more solid wooden bridge with 11 arches opened in 1788. It would last for nearly 90 years, making a healthy profit from tolls, with as much as £300 being taken in one day when there was horse racing nearby. The concession for the bridge toll was auctioned annually at The Mitre Hotel, which still stands at the north end of the bridge. Work on a third a wrought-iron lattice girder bridge supported by four cast-iron columns began in May 1864. It opened in April 1865 and was described as 'one of the ugliest bridges in England'. It was later bought for £48,048 by the Hampton and Molesey Local Boards and the Corporation of London. By 1923 the age of the motor car meant a new bridge became necessary and a 1928 Act of Parliament gave permission to build it plus new bridges at Twickenham and Chiswick. Work on the fourth bridge, just downstream from its predecessor, began in September 1930. The triple-span Sir Edward Lutyens-designed bridge is built of concrete and Portland Stone with a red brickwork facing to ensure harmony with Hampton Court Palace.

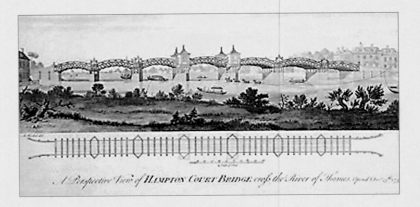

A Perspective View of HAMPTON COURT BRIDGE over the River of Thames

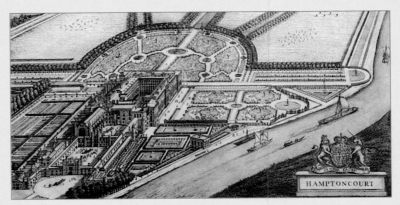

HAMPTONCOURT

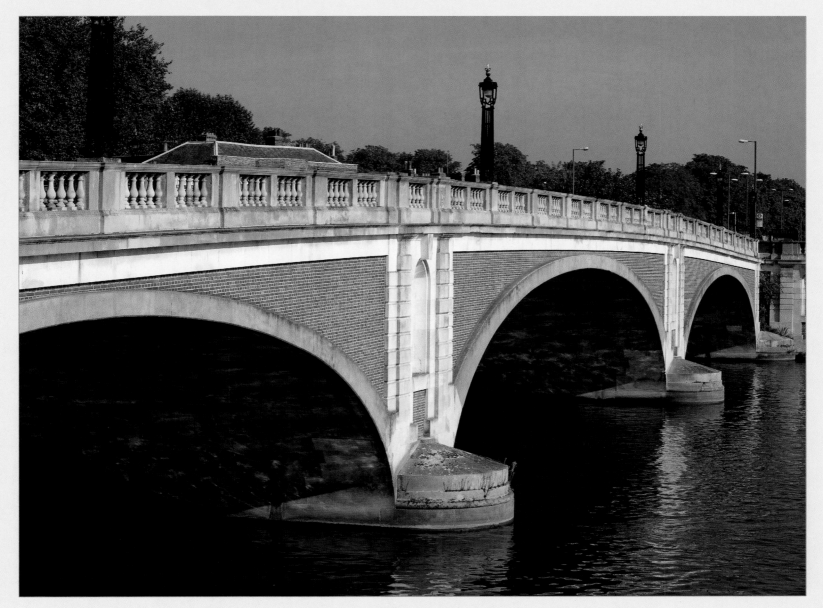

The 'Bridge Builders'

Peter de Colechurch 1130 - 1205

London Bridge (1176 - 1209)

Colechurch was Chaplain of St Mary's Colechurch, Cheapside and head of the Fraternity of the Brethren of London Bridge. He was responsible for the maintenance of the last wooden bridge, which had been built under his direction in 1163. He started to construct a new stone bridge during Henry II's reign in 1176, building a chapel on the bridge dedicated to St Thomas Becket. The chapel had an upper floor at street level and a crypt that was accessible from the river. A spiral staircase joined the two floors. He died in 1205, four years before the bridge was completed and was buried in the new crypt of St Thomas's Chapel on London Bridge. When the bridge was eventually pulled down in 1831 his bones were unceremoniously thrown into the river.

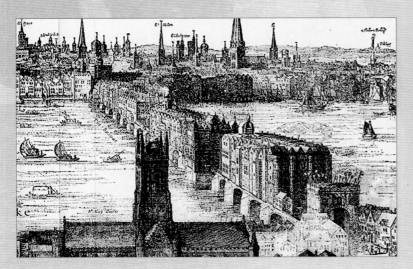

James Paine 1717 - 1789

Richmond Bridge (1777)

Kew Bridge (1789)

James Paine, the son of a carpenter, was born in Andover in 1717. After training as an architect in London he went on to restore many large country houses before he designed the Doncaster Mansion House and Dover House in Whitehall. In 1760 he designed Shardlow Bridge over the river Trent before becoming the architect of Richmond Bridge, which opened in 1777 and designing the second Kew Bridge in 1789.

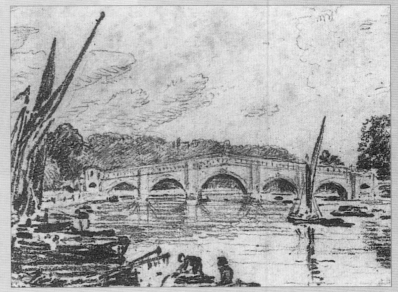

John Rennie 1761 - 1821

Waterloo Bridge (1811-1817)
Southwark Bridge (1815-1819)
design for London Bridge (1824)

Rennie was born about twenty miles from Edinburgh on 7 June 1761. He regularly missed school to watch Andrew Meikle the inventor of the threshing machine at work in his millwright's yard. He was a brilliant mathematician who started his own business and used the money from his earnings to put himself through Edinburgh University. In 1783 he left Scotland on horseback to find engineering work in England.

He worked for James Watt before again working for himself, this time developing and building machinery powered by steam engines built by Matthew Boulton and Watt. He quickly gained a reputation as a bridge designer and builder using cast-iron and stone to design bridges with wide arches. He designed and built the Lune Aqueduct (1793-97) and Kelso Bridge (1800-1804) before designing Waterloo, Southwark and London Bridge (which was built by his son following his death). Rennie was one of the first men to use structural cast-iron, and his confidence and accuracy meant he was probably the greatest engineer of the Industrial Revolution. He died on 4 October 1821.

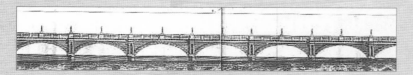

Sir Charles Barry 1795 - 1860

Westminster Bridge (1855 - 1862)

Charles Barry, who was born in Bridge Street Westminster in 1795, was apprenticed to a London surveyor when he was fifteen. Following this and having been left a legacy by his father he then travelled extensively throughout Italy, France, Turkey, Syria, Egypt, Palestine and Greece studying architecture. He returned to England in 1824 having won the commission to design the Royal Institution in Manchester, which became the City Art Gallery. His work was now clearly influenced by the Italian Renaissance. He designed the Travellers Club in 1832 and London's Reform Club in 1838. Following the fire at the Palace of Westminster in 1834 Barry and Augustus Welby Pugin won the commission to design and build the new House of Commons and House of Lords including the clock tower, which houses Big Ben: this is without doubt Charles Barry's most famous building. He designed Trafalgar Square in 1840 and the Cabinet Office in 1845, and the Charing Cross Hotel on the Strand. He was knighted in 1852 and was appointed consulting architect for the new Westminster Bridge in 1853 to ensure empathy with his Palace of Westminster. The first section of the Thomas Page built bridge was opened in March 1860 just before Barry's death. The bridge was finally completed in 1862. Barry lived and died in 'The Elms', a house on Clapham Common North Side, where there is a blue plaque today. His ashes were interred in Westminster Abbey. Three of his four sons followed him into architecture and building.

Sir John Hawkshaw 1811 - 1891

Hungerford Bridge (1864)

Cannon Street Railway Bridge (1866)

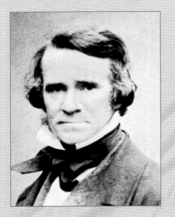

Hawkshaw, the son of a publisher, who was born in Leeds, became interested in the railways as a young man. He started his own business as a consulting engineer in 1850 and became chief engineer of the South Eastern Railway between 1861 and 1881. Hawkshaw was responsible for many land drainage and flood prevention schemes throughout the UK and was also responsible for the design of Holyhead Harbour. He designed three Thames bridges Hungerford Bridge, Cannon Street Railway Bridge and Staines Railway Bridge. He was knighted in 1873.

He went on to design the southern dock basin at the West India Docks in London and advised the Viceroy of Egypt about the Suez Canal project. Towards the end of his career he worked on an early proposal for a channel tunnel.

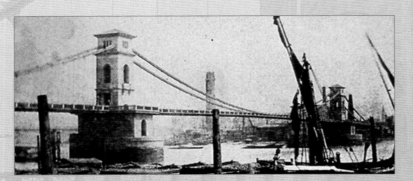

Sir Joseph Bazalgette 1819 - 1891

Putney Bridge (1882-1886)

Hammersmith Bridge (1887)

Battersea Bridge (1890)

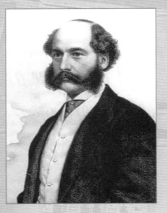

Joseph Bazalgette was born in Enfield in 1819, the son of a Royal Navy captain and grandson of a Frenchman who had escaped the French Revolution. Following an apprenticeship with Sir John MacNeil he started his own engineering consultancy in 1842 and worked on the expanding railway network throughout the 1840s.

He was appointed chief engineer to the Metropolitan Board of Works in 1856. His first and most important task was to solve London's sewage disposal problem, the system being totally inadequate. Outbreaks of cholera and other diseases were killing thousands every year. In 1858, the year of the 'Great Stink', parliament passed an act allowing his plans for 1,300 miles of sewers.crossing the city. Foul water from the old sewers and underground rivers was intercepted and diverted into modern low-level sewers. It was then taken to new treatment works.

The Prince of Wales opened Bazalgette's new sewage disposal system in 1865. It was one of the great feats of Victorian engineering and much of it is still in use today. It was his most famous contribution to architecture although he went on to design the Victoria and Chelsea Embankments as part of his great drainage scheme for London.

He was knighted in 1875 before he designed Hammersmith, Putney

and Battersea bridges and strengthened Albert Bridge. Bazalgette was still working as an engineer when he died in Wimbledon in 1891 aged 72. There is a monument honouring this remarkable man on the Victoria Embankment, as well as a blue plaque outside of one of his earlier homes in St John's Wood.

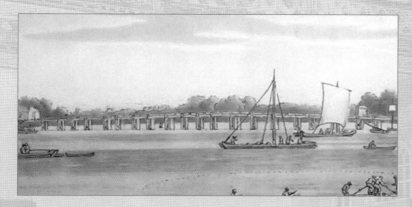

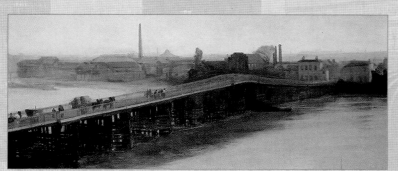

Sir Horace Jones 1819 - 1887
Tower Bridge (1886 -1894)

Jones who was born in London was apprentice to William Tite the architect of the Royal Exchange. He opened his own architectural practice in 1842 and became well respected for his work as architect of the Corporation of the City of London from 1864 to 1887. He restored the Great Hall of the Guildhall in 1866, the same year that he designed Smithfield Market. He restored Billingsgate market in 1875 and Leadenhall market in 1881. He designed the Guildhall library and museum in 1872 and the Guildhall Council Chamber in 1884. Horace Jones was President of the Royal Institute of British Architects and was knighted in 1885.

He designed Tower Bridge and saw the building start in 1886, but he died the following year and never saw his bridge finished. The engineer on the project, John Wolfe-Barry took over responsibility for the bridge and completed it in 1894. In so doing he changed Jones's simple and medieval design considerably. When the bridge was first finished it was unpopular with the public, and was described as 'monstrous and preposterous' by The Builder magazine. However, it soon became one of Britain's and the world's most loved landmarks.

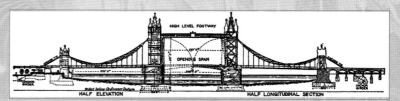

Sir John Wolfe-Barry 1836 - 1918

Cannon Street Railway Bridge (1866)
Blackfriars Railway Bridge (1886)
Tower Bridge (1887), Kew Bridge (1903)

John Wolfe-Barry the youngest son of Sir Charles Barry was a pupil of Sir John Hawkshaw. He worked with Hawkshaw on many projects, including Charing Cross and Cannon Street Railway Bridges. In 1878 he went into partnership with Henri Marc Brunel, the second son of Isambard Kingdom Brunel. When Sir Horace Jones died in 1887 Barry took over the design and building of Tower Bridge adding his own design and flair to Jones's work. It was Tower Bridge that made John Barry's name.

He also designed Kew Bridge, Blackfriars Railway Bridge, Barry Docks near Cardiff and the District Line of the London Underground. Other commissions included the expansion of Greenland Dock (now the Surrey Docks) and the design of some of the stained glass windows in Westminster Abbey. He was elected president of the Institute of Civil Engineers in 1896 and was knighted in 1897. He added Wolfe to his inherited name in 1898. From 1900 to 1917 he was Chairman of Cable & Wireless. He was described in his obituary as 'the leader of his profession in Great Britain'.

Sir Edwin Lutyens 1869 - 1944

Hampton Court Bridge (1930 -1933)

Edwin Lutyens was born in Onslow Square London, the tenth child in a family of thirteen, as a boy his time was spent between London and Thursley in Surrey.

He suffered badly with rheumatic fever and never went to school or university but was taught instead by his sister's governess. In 1885 he went to the South Kensington School of Art (later to become the Royal College of Art) before becoming an articled pupil to Sir Ernest George in 1887. He started work as an architect in 1889 when he was twenty and because he had few outside interests it was the start of a prolific output of brilliant work. Lutyens built Castle Drogo and remodelled Lindisfarne Castle; he designed more than 36 large English country houses. He was responsible for designing the Cenotaph in Whitehall and many other WWI memorials and cemeteries. He designed the Viceroy's House in New Delhi, the British Embassy in Washington and the Johannesburg Art Gallery. His design of the fourth Hampton Court Bridge ensured an empathy with Hampton Court Palace with matching red bricks. He also took delight in working on smaller projects such as Queen Mary's doll's house, which is now in Windsor Castle. Perhaps his life's greatest work was a design for Liverpool Cathedral of which only the crypt was built. He died in 1944.

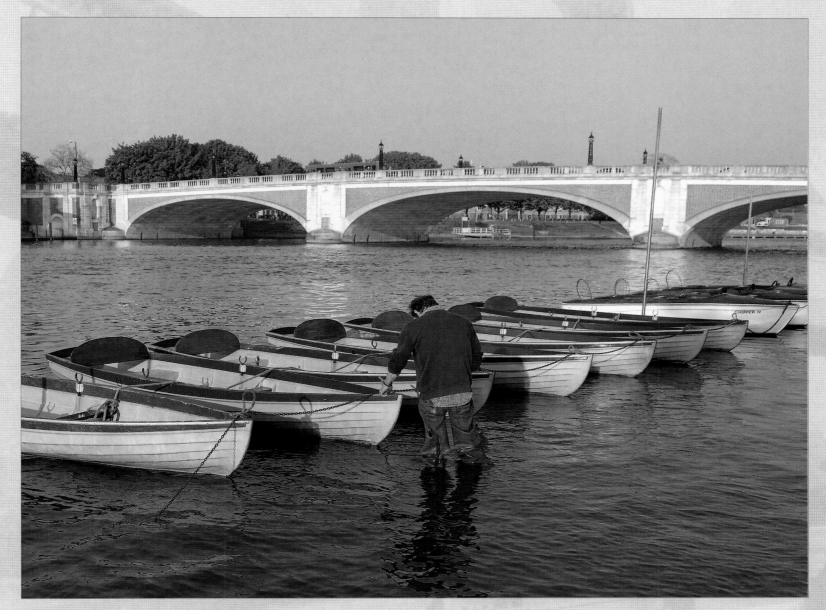

The Metropolitan Board of Works (MBW)

The MBW was set up as a result of the Metropolis Management Act in 1855. It was an unelected body, responsible for many of London's central services, including roads, slum-clearance, sewage and bridges. Sir Joseph Bazalgette was appointed chief engineer in 1856. An Act of Parliament in 1869 gave the MBW and the Corporation of London the authority to purchase Hampton Court and Kingston Bridges. Over the next ten years they would also buy another ten bridges including: Kew for £57,300, Wandsworth for £53,311, Lambeth for £35,974, Hungerford for £98,000, Vauxhall for £255,000, Hammersmith for £112,000 and Waterloo for £474,000 (just over half of the bridge's original cost). They also bought Battersea, Albert and Putney bridges. The Prince of Wales declared Hammersmith, Putney and Wandsworth Bridges all free from tolls at individual ceremonies on the same day 26 June 1880, the last of London's road bridges to be freed from tolls. In total the MBW paid out £1,376,825 to free London's toll bridges. It was never given an official coat of arms but it regularly used a crest with the Royal Arms in the middle and the insignia of the other bodies it was working with on the outside. In 1889 the London County Council replaced the MBW. In 1964 the Greater London Council took responsibility from the London County Council, and when the GLC was abolished in1986 the bridges were returned to the control of local councils.

Thwaites was the founder Chairman of the MBW. He was a businessman and local councillor and took responsibility for the planning of London's new sewage system. Hogg succeeded Thwaites as Chairman and directed the programme of purchasing the bridges and freeing them of tolls.

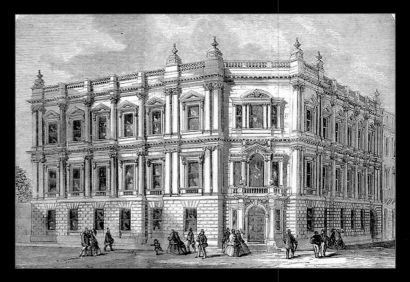

The Metropolitan Board of Works' headquarters, 1860

Sir John Thwaites, 1858

James Macnaghten Hogg, 1887

This body owns and maintains five London Bridges: Tower Bridge, London Bridge, Southwark Bridge, the Millennium Bridge and Blackfriars Bridge. The Trust is a registered charity dating back to 1097 when William Rufus introduced a tax specifically to repair the then wooden London Bridge. In those days it was commonplace for wealthy London citizens to leave legacies of money and land 'to God and the Bridge'. This was seen as an act of piety because throughout history the church had encouraged bridge building. It is also why Peter de Colechurch, a priest and Head of the Fraternity of London Bridge, built the first stone bridge across the Thames in London. The Trust, which was granted a Royal Charter in 1282, collected funds from home and shop rents on London Bridge, as well as from tolls imposed on pedestrians and wagons crossing the bridge. Throughout history the Trust was closely linked with the history of London Bridge. The fund's administrative headquarters was based in Bridge House on the south side of the bridge, and from this the Trust became known as the Bridge House Trust.

The Trust went on to buy Southwark Bridge for £200,000 in 1866 and funded the building of Joseph Cubitt's new Blackfriars Bridge in 1869 and Tower Bridge in 1894. In February 2002 it took over the ownership and maintenance of the new Millennium Bridge. It now has assets of over £700 million, and gives away more than £15 million every year to London charities. The Bridge House Trust flag flies proudly from Tower Bridge. The trust was recently re-named The City Bridge Trust.

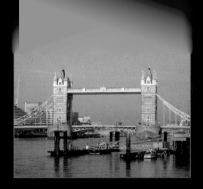

Tower Bridge

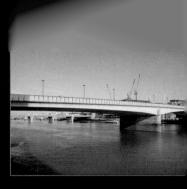

London Bridge

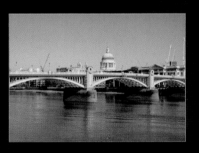

Southwark Bridge

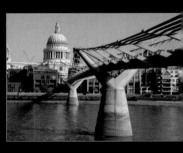

Millennium Bridge

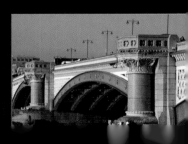

List of bridges from Tower Bridge to Hampton Court Bridge

Bridge	Year of Original Bridge	Year of Current Bridge	Designer of Current Bridge	Length (feet)	Width (feet)	Description of the current bridge
Tower	1894	1894	Sir Horace Jones	880	60	Double-bascule leaf bridge with twin towers
London	1209	1973	Lord Holford	860	105	Three spans of pre-stressed concrete cantilever arches
Cannon Street RB	1866	1982	British Railways	855	82	Five wrought-iron spans
Southwark	1819	1921	Sir Ernest George	800	55	Five steel arches
Millennium	2000	2000	Foster and Partners	1,066	15	Suspension bridge with eight suspension cables
Blackfriars RB	1864	1886	W Mills	933		Five wrought-iron spans
Blackfriars	1769	1869	Joseph Cubitt	963	105	Five elliptical wrought-iron arches
Waterloo	1817	1945	Sir Giles Gilbert Scott	1,230	80	Five arches with reinforced concrete beams
Hungerford	1845	1864	Sir John Hawkshaw	1,200		A railway bridge with eight tracks
Jubilee	2002	2002	Litschutz Davidson	1,066	15	Two pedestrian bridges either side of the railway bridge
Westminster	1750	1862	Sir Charles Barry	827	84	Seven elliptical cast and wrought-iron arches
Lambeth	1862	1932	Sir George Humphreys	776	60	Five steel arch spans
Vauxhall	1816	1906	Sir Alexander Binnie	809	80	Five steel arches
Grosvenor RB	1860	1965	Sir John Fowler	700	230	Quadruple wrought-iron span railway bridge
Chelsea	1858	1937	G Topham Forest	698	83	Suspension bridge
Albert	1873	1873	Roland Mason Ordish	710	40	Triple span iron suspension bridge
Battersea	1771	1890	Sir Joseph Bazalgette	670	55	Five wrought-iron and steel cantilever arches
Battersea RB	1863	1863	William Baker	670		Five lattice girder arches
Wandsworth	1873	1940	Sir Peirson Frank	664	60	Triple span cantilevered bridge
Putney RB	1889	1889	W H Thomas/W Jacomb	750		Five wrought-iron lattice girders
Putney	1729	1886	Sir Joseph Bazalgette	700	74	Five arches
Hammersmith	827	1887	Sir Joseph Bazalgette	700	43	Suspension bridge
Barnes RB	1849	1895	London & South West Railway	360		Three wrought-iron spans

Chiswick	1933	1933	Sir Herbert Baker	607	70	Triple span bridge
Kew RB	1869	1869	W R Galbraith	575	28	Five wrought-iron spans
Kew	1759	1903	Sir John Wolfe Barry	1,182	56	Three elliptical arches
Richmond Lock	1894	1894	James More	300	28	The footbridge has five arches and crosses both the lock and barrier
Twickenham	1933	1933	Maxwell Ayrton	280	70	Three ferro-concrete arches
Richmond RB	1848	1908	J W Jacomb-Hood	300		Two separate 3 span steel-arched bridges each carrying one line
Richmond	1777	1777	James Paine	300	36	Five arches
Teddington Lock	1889	1889	G Pooley			Two separate foot bridges meet on the island
Kingston RB	1863	1863	J E Errington	375		Five cast-iron arched ribs
Kingston	c1215	1828	Edward Lapidge	382	79	Five elliptical arches with floodwater arches on each side
Hampton Court	1753	1933	Edwin Lutyens	313	70	Three arches

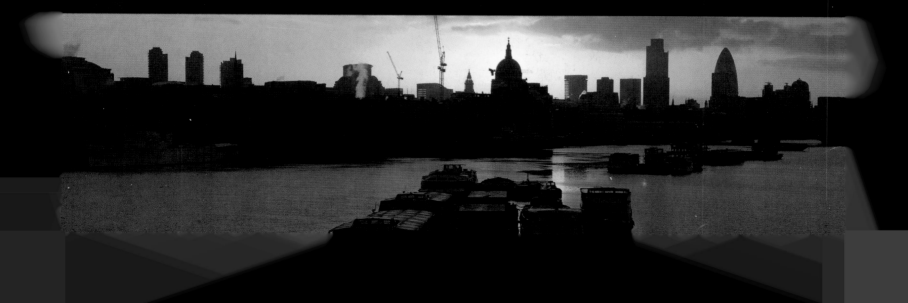

Acknowledgements

In writing and compiling this book I owe a huge debt of gratitude to many people,
but I particularly thank Marie and Claire for all the many hours spent proof reading,
to Liam McCann for his fine editing, to Maggie, Ronald and Tim, the crew of 'Breezing In' for
so kindly ferrying us up and down the Thames examining the bridges at close hand,
to Niki Nekuda for his brilliant design work, to Cameron Brown for his kind and calm encouragement
but especially to Sam and Keith for their wonderful and innovative new photographs
which really do show the history of London's Bridges.